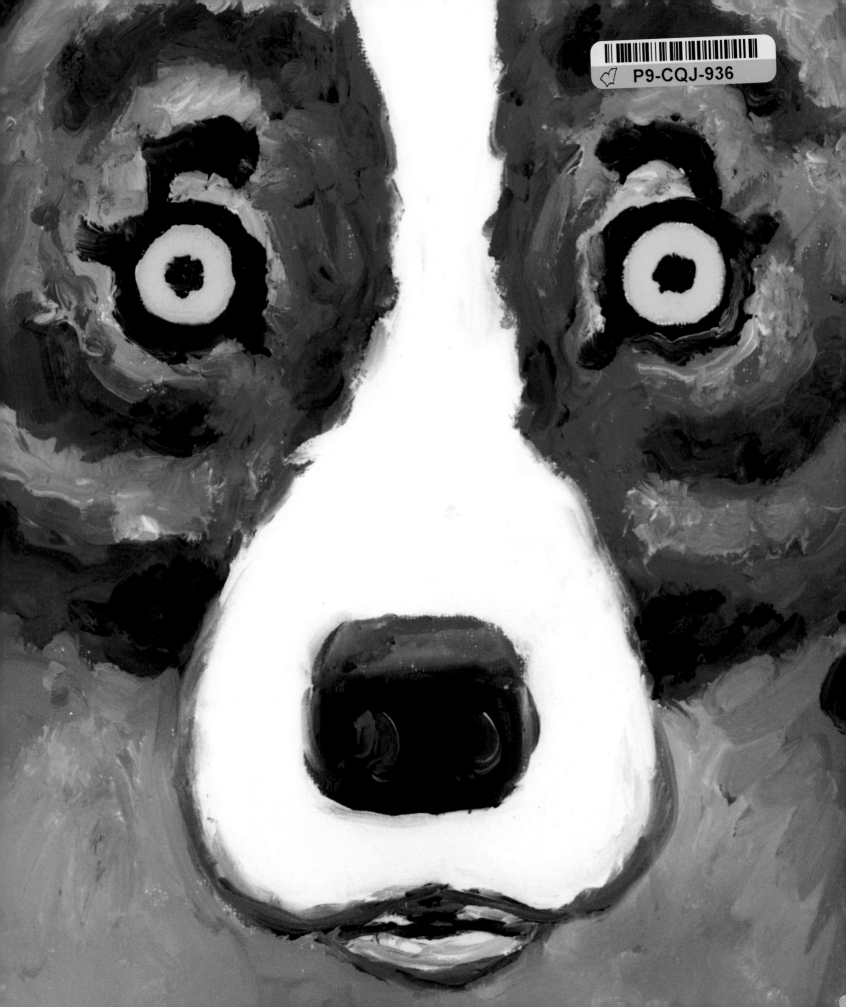

BLUE DOG

BLUE

Paintings by
George Rodrigue

DESIGNED BY
ALEXANDER ISLEY
DESIGN

GEORGE
RODRIGUE
and
LAWRENCE S.
FREUNDLICH

PENGUIN
STUDIO

PENGUIN STUDIO
Published by the Penguin Group
Penguin Books USA Inc., 375 Hudson Street,
New York, New York 10014, U.S.A.
Penguin Books Ltd, 27 Wrights Lane,
London W8 5TZ, England
Penguin Books Australia Ltd, Ringwood,
Victoria, Australia
Penguin Books Canada Ltd, 10 Alcorn Avenue,
Toronto, Ontario, Canada M4V 3B2
Penguin Books (N.Z.) Ltd, 182–190 Wairau Road,
Auckland 10, New Zealand

Penguin Books Ltd, Registered Offices:
Harmondsworth, Middlesex, England

First published in the United States of America by
Viking Studio Books, an imprint of Viking Penguin,
a division of Penguin Books USA Inc. 1994
Penguin Studio edition published 1997

1 3 5 7 9 10 8 6 4 2

Some of the illustrations in this book first appeared in
Der Blaue Hund by George Rodrigue, published in 1992 by Rogner
& Bernhard GmbH & Co. Verlags KG, Hamburg, Germany.

THE LIBRARY OF CONGRESS HAS CATALOGUED THE HARDCOVER AS FOLLOWS:
Rodrigue, George
Blue dog/George Rodrigue and Lawrence S. Freundlich;
paintings by George Rodrigue.
p. cm.

1. Rodrigue, George. 2. Painters—Louisiana—Biography.
3. Tiffany (Dog) 4. Tiffany (Dog) in art. 5. Dogs—Louisiana–
–Biography. I. Freundlich, Lawrence S. II. Title.
ND237.R69A2 1994
759.13—dc20
[B] 93-39794

ISBN 0-670-85538-3 (hardcover)
ISBN 0-670-86621-0 (signed edition)
ISBN 0-140-26550-3 (paperback)
Printed in Japan

To my sons, Andre and Jacques —G. R.

To those dear but anonymous friends who promise to
love us until we can love ourselves —L. F.

ACKNOWLEDGMENTS

Many thanks to Richard Steiner and the people of the Rodrigue Gallery of New Orleans: Theresa Guillot, Karen Naquin, Judith Proctor, and Douglas Shiell. Thanks also to Sandra Crake and Wendy Wolfe of Galerie Blue Dog, Carmel; Heike Alexander of Galerie Blue Dog, Munich; and Kazuko and Shoko Sato of The Blue Dog Gallery in Yokohama.

A special thank you to Linda Kuykendall, Beverly and Steve Friedman, Bertha Bernard, Romaine Fruge, Alice Bernard, and my mother for all the support they have given me over the years.

I am also grateful to Roz Cole and Larry Freundlich, who made this book possible, and to those at Viking Studio Books and Penguin USA for their hard work: Barbara Williams, Michael Fragnito, Peter Mayer, and their staff.

I remain deeply grateful to those who have enjoyed and collected my work throughout the years. —G. R.

I would like to express my gratitude to Edward Rice, who shared with me his knowledge of the four-eyed dog. —L. F.

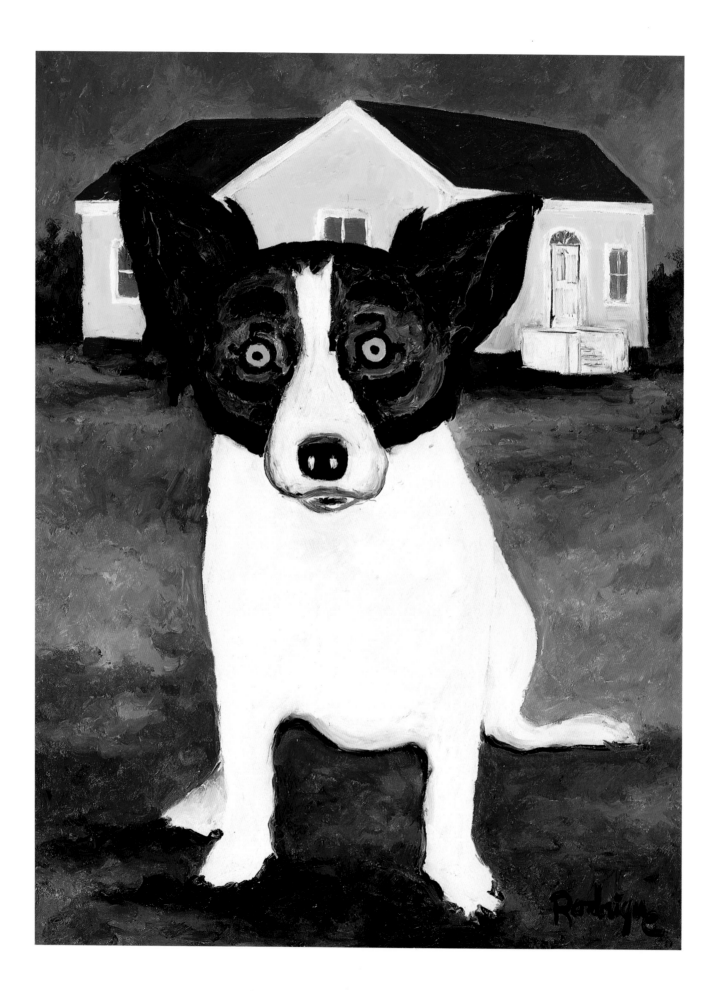

one

You know her as "Blue Dog," but when she first entered my life she went by the name "Tiffany," a black-and-white cross between a spaniel and a terrier, and she filled my life with a rambunctious joy that made being sad around her almost impossible.

When it came to loving, Tiffany was totally uncritical. If I tried to throw out a pair of my old slippers, Tiffany would fetch them from the trash bin and secretly hide them at the back of the closet, where I kept her favorite blanket. The same for my old baseball caps, worn-out brushes, ripped T-shirts, and work gloves. And when I tried to take them away from her, she would lower her eyes and droop her head and moan piteously. She would follow me out to the trash and look up at me as if imploring me not to drown her puppies. It wasn't worth it for me to show her who was boss. She beat me down, and I would give in and let her have the slippers or the hat or the T-shirt. And the minute I did, she would shiver with joy and drag those disgusting old things back to her closet, her tail wagging like a windshield wiper in a downpour.

And as loving as she was to me, that's how fierce she was to anything she considered an enemy. She never lost her wild side. She would face down raccoons who would have torn her to shreds if I hadn't dragged her away, and on still nights, when wild dogs would bark across the bayous, she would run

into my bedroom and pull at the covers, wanting me to let her out to do battle. At such moments, I didn't know whether to laugh or to scold her.

When Tiffany was a puppy, she was such a whirling dervish that I had to bar her from my studio. She would yap and sniff 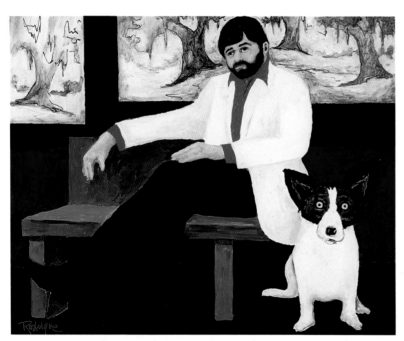 and chase her tail. She would snuffle around the canvases stacked against the walls as if she were trying to corner a rodent. I was always afraid that she'd get her paws in the oil paint or chew a canvas. But I lost that battle also. I couldn't stand her scratching at the door and I couldn't bring myself to hit her. My brain-

storm was to paint a picture of the two of us together, and I propped it up right near her dog basket in the studio. The minute she saw it, she seemed mesmerized, and from that time on, she would sit quietly in the studio, never making a sound or a sudden move until I would summon her for a scratch around the ears.

In the last days of her sickness, even as death approached, she was more concerned with loving me than begging for relief from her suffering. One morning, I was painting in the studio. Tiffany was curled up in her basket, her head resting on her paws, her sad eyes looking at her favorite painting. My back was toward her, the slanted northern light gently warming me. I stopped my work, and unthinkingly snapped my fingers to bring her over for a scratch. But this time, she didn't come to me.

Today is the anniversary of Tiffany's death. I have spread out before me several images of what in Persian and Indian religious mythology is called "the four-eyed dog." These images were sent to me by a friend and scholar of the East shortly after Tiffany died, when I had begun to have troubling dreams about her. He, too, had recently lost a loved one—his lovely, adoring wife, more than twenty years his junior. We shared our feelings with one another. He told me that just before his wife's death, she told him that she had been dreaming, night after night, of a four-eyed dog. Because he had been doing research for an upcoming book, my friend knew that the four-eyed dog was a Zoroastrian symbol of death. He could not dismiss his wife's dream, nor did he dare share this fateful premonition. Within weeks, his wife was dead.

However, in showing me the four-eyed dog, my friend was not introducing me to a morbid curiosity, but to something else he had learned about the symbol of the four-eyed dog as it was adopted by Hindu India. He told me of the "Horse Sacrifice," the *As'vamedha*. A rajah would breed a pure white horse, and when it had grown to full size, he would order a hundred princes to gather one hundred warriors from each rank of his army: bowmen, lancers, cavalry. The wild white horse was let loose and chased by the princely retinue. Wherever the horse stopped, the army entered into battle and claimed that land for their rajah. At the end of the campaign, the princes ordered the horse captured and returned to the rajah for sacrifice. The horse needed to be cleansed of evil spirits before it could be offered up for thanksgiving, and for this purpose a priest-shaman painted the symbol of the four-eyed dog on the horse's side. The dog's two-fold vision enabled it to be a guide between this life and the next.

In the days and nights following my first reflections on the four-eyed dog and the links between life and death, my feeling of connection with Blue Dog grew ever more urgent. Whether my subsequent dreams were the waking dreams of a painter, the inward eye rolling into the resources of the soul, or the dreams of real night-time sleep, I cannot say to this day. As a painter, I had trained myself to accept images from whatever source, be it an object in the world of nature or the promptings of dreams. An image for me was no less real because it had been initiated by the subconscious, and I gave no priority

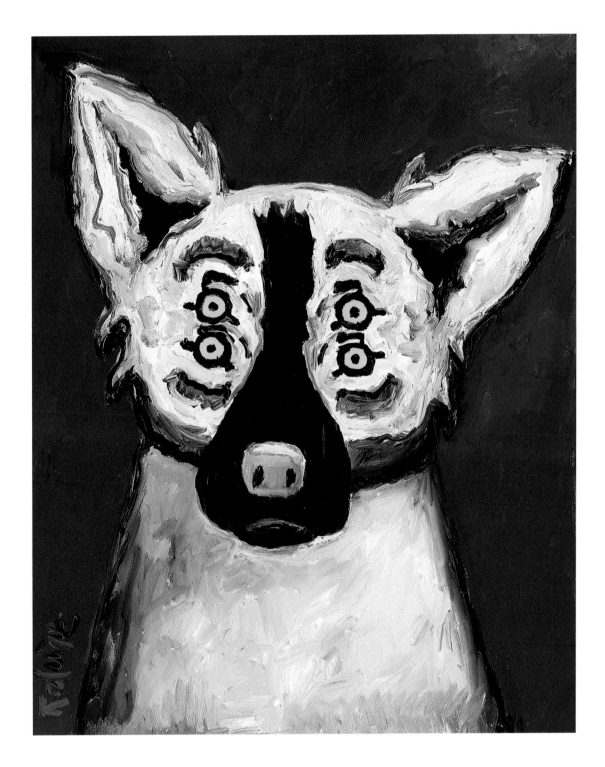

to one over the other. In all these dreams or reveries, as my painter's hand and eye fashioned the land-

scapes and the people of my Cajun land and culture, I sensed a beckoning prophecy rippling over

the bayous and the black oaks, through the hanging moss and along the wakes of fragile pirogues,

"To find her you
must lose her.
The Blue Dog
knows the way."

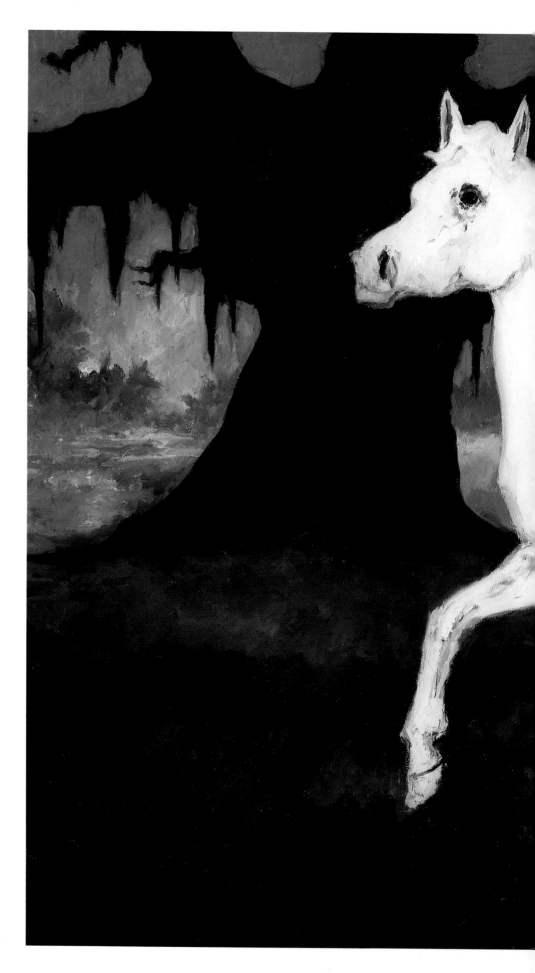

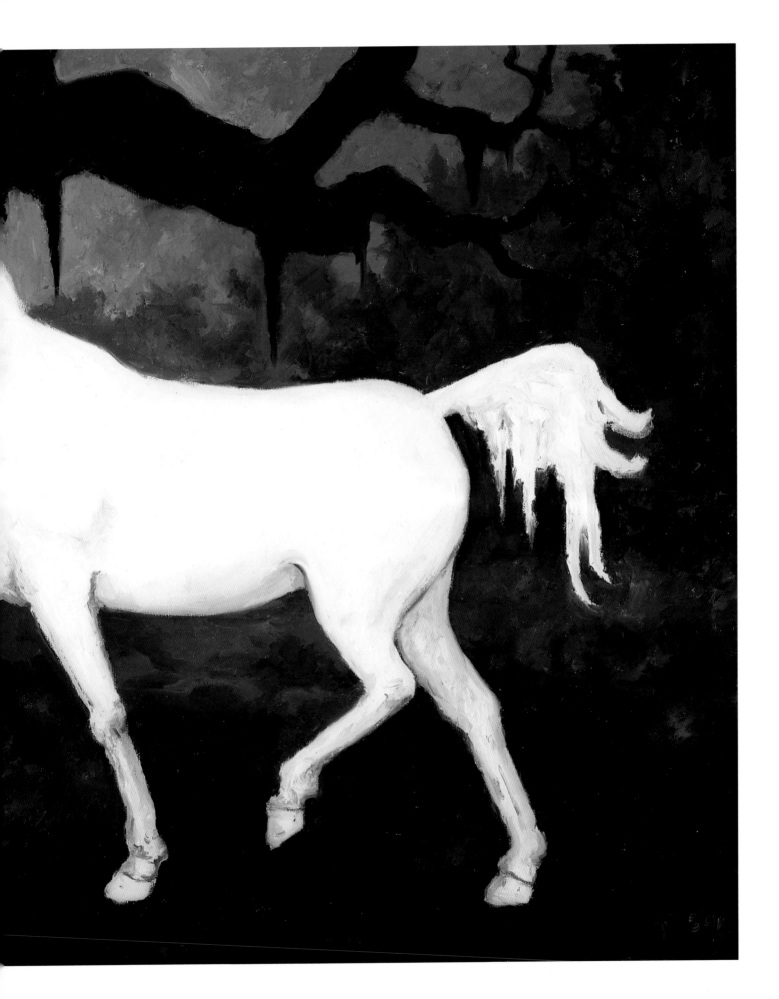

two

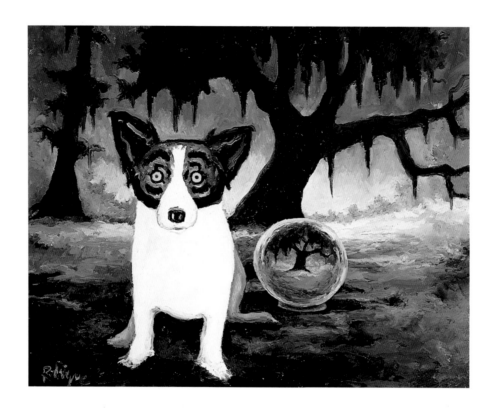

"TO FIND HER YOU MUST LOSE HER. THE BLUE DOG KNOWS THE WAY." I COULD NOT rid my heart and mind of that haunting prophecy. As I painted, I felt that Tiffany's spirit was crying out for my help—that she hadn't comprehended the meaning of her death, and was wandering the spirit world in search of a peace that only I could give her. I longed to be close to her mystery, and soon my canvases, like Ouija boards communicating messages from a world beyond our senses, began to bear the imprint of my groping efforts to respond to her cries for guidance.

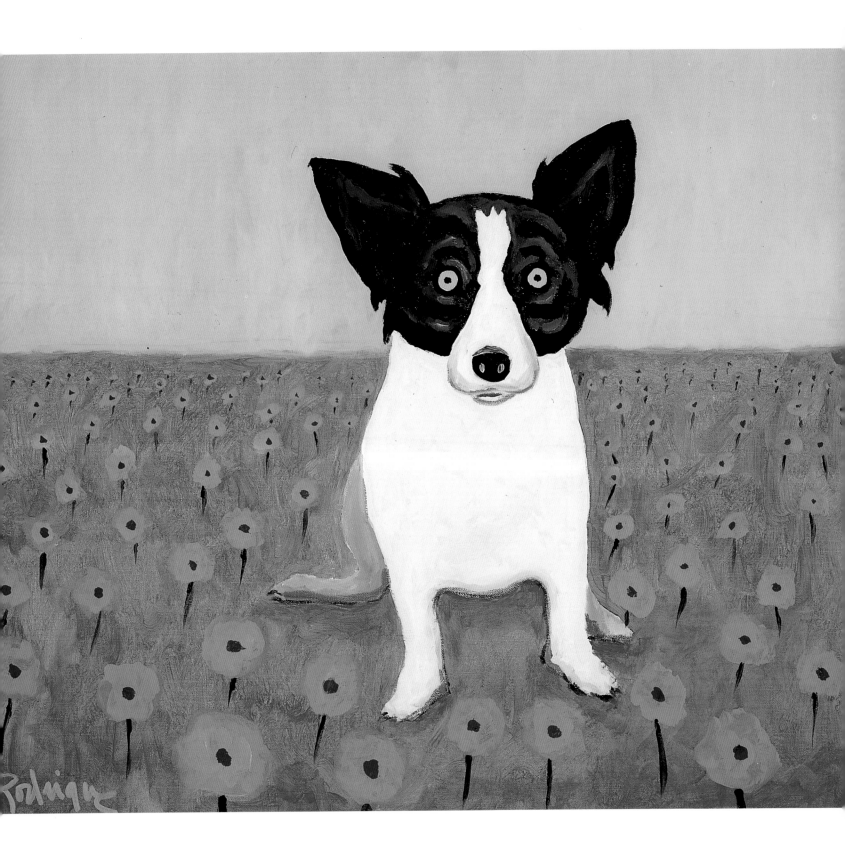

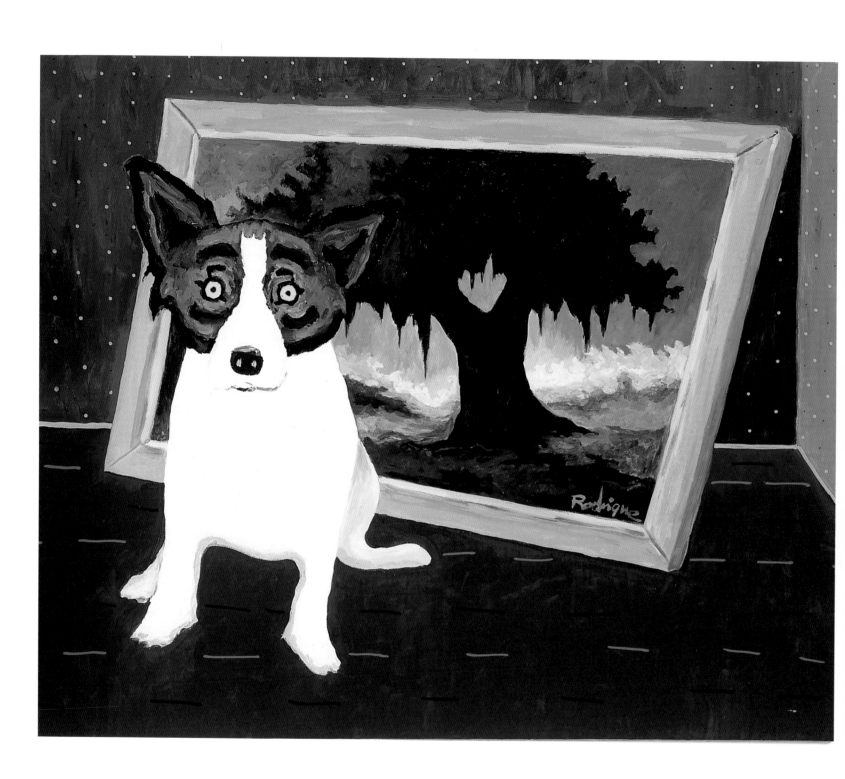

three

IT WAS SO LONG BEFORE I COULD GET ON GEORGE'S WAVELENGTH. HE KEPT painting the way he always had. When I was still alive, I used to sit in George's studio, my eyes never letting him out of my sight as he filled canvas after canvas with startling, brooding scenes of Cajun country. I loved him so much, I wanted to be in those paintings, to be a part of his life. But in life I had no way to tell him.

George had no idea how to help me, despite my desperate desire to be reunited with him. And I had no way of guiding him to any answers. All I had was trust in his love for me, and a feeling that somehow this love might be sufficient to reunite us. The best I thought I could do was to get as close to him as possible, and hope he would become aware of the beating of my heart. Perhaps he would sense my gaze upon his face as he had during those countless afternoons when he had let me sit by his side in the studio.

The paintings were the key, I thought. It was in them that his soul was vulnerable and opened wide. It was there that our spirits might find a bridge across the barrier. The paintings. They were my best and only chance. George may have come to think that it was he who had made the decision to include me in his new paintings, but the idea was really mine.

four

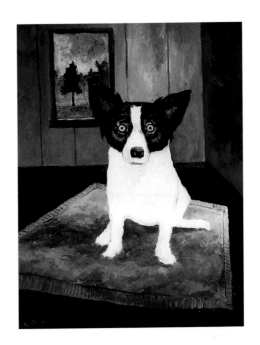

WHEN A DOG LOVES HER MASTER, IT'S JUST ALL-OUT LOVE. SHE DOESN'T HOLD anything back. She won't stop licking you until you literally push her away. She never can get enough of your petting. A dog has no distance between her love and her behavior. No amount of love is too much, either to give or to receive. That's why a dog needs discipline, so she doesn't make an idiot of herself. These thoughts never occurred to me when Tiffany was alive, but since her death I've become more human, in a way. Always there's

that space between what you feel

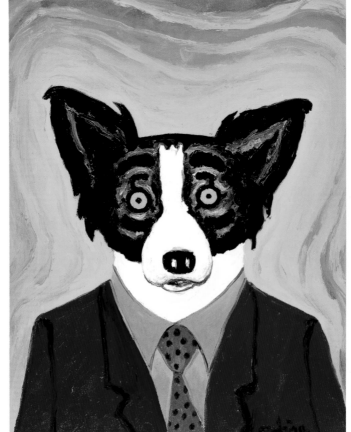

and what you do,

and in that gap
all human
sadness lies.

At least that's what I think.

five

WELL, GEORGE'S CAJUN TABLEAUX HAD BEGUN TO MAKE HIM A GOOD DEAL OF money and an international reputation. One afternoon he invited a very wealthy English peeress, vacationing in New Orleans for Mardi Gras, to look at some of his classic Cajun paintings. She wanted to buy his portrait of Diane Bernard posing as Evangeline, who was immortalized by Longfellow in his poem about the odyssey of the Cajun exiles.

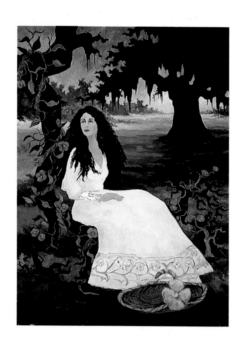

"Scattered

like dust

and leaves..."

George kept me right by his side, and, as usual, I licked his fingers and let him feed me pieces of leftover sandwiches. The peeress made the mandatory cluckings over my cuteness, and remarked how nice it must have been for George to have my company during the "lonely process of creation." Yes, I wanted to say to George, aren't you lucky to have me around? And isn't it true that without me, none of this would be possible? Of course, George paid me no heed.

Then the peeress told a story that in retrospect almost breaks my heart. It seems she had an artist sister who was once painting a picture, illustrative of a passage in "Paradise Lost," in which Satan is "squat like a toad" at the ear of Eve. In order to have a live model, she had ordered a toad to be delivered by mail to the estate, and it had just arrived. Shortly afterward, to her great annoyance, she discovered that a small boy who was sitting as a model for a cherub's head was naughtily pinching the toad, which she promptly and with great feeling rescued. And the toad seemed to understand and

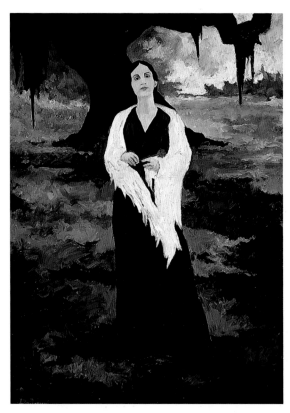

appreciate her intervention. In the days that followed, whenever she approached, the toad blinked at her with an affectionate gaze and hopped toward her; so that after he had played his part as a model he remained on as a friend, living in the garden. But it was his strange habit that, at intervals, he visited the house in obvious anxiety to find out if she was still there. From time to time, he would be found seated on the doorstep, waiting patiently till he could enter; and his mistress gave orders that the toad was always to be admitted. So, in the midst of her work, there would come a knock at the door with the information,

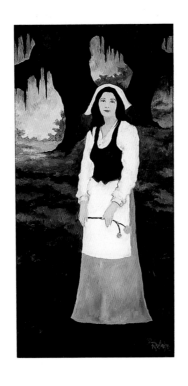

"Please, ma'am, the toad is called!"

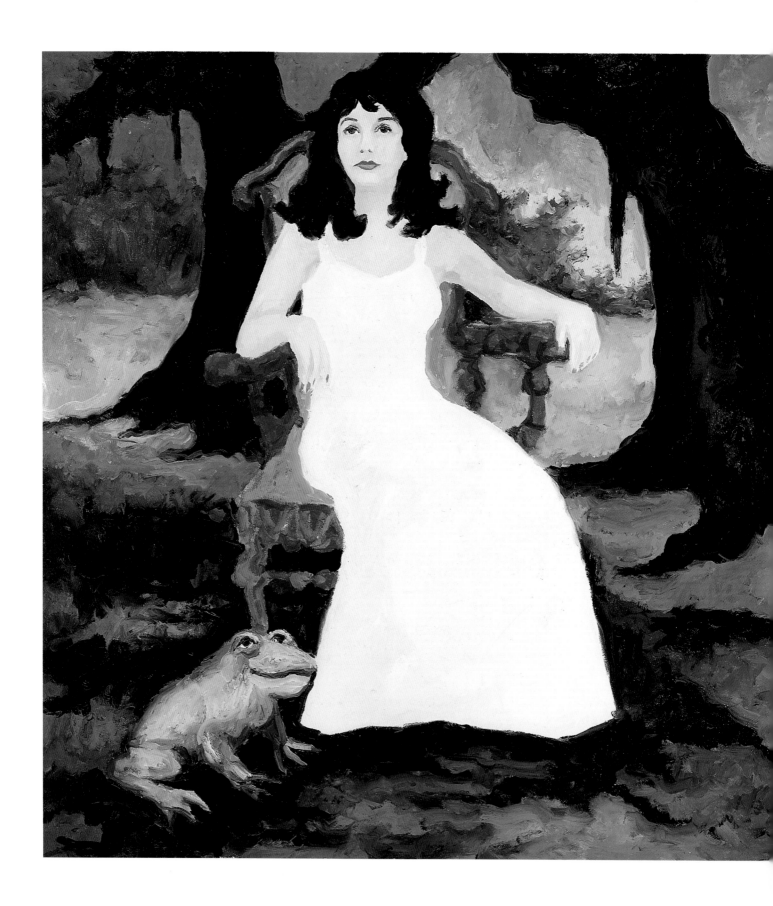

and then the creature would hop into the room, look up in her face, and after a while hop out again, satisfied.

The peeress told George that "this ended only after some years, when the toad apparently paid the debt of nature, for it came no more."

George, amused by the story, taken by the beauty of the peeress, and probably contemplating a large sale, ran his fingers over my ears as if I were a stuffed doll, unaware of my infinite devotion. If a toad could be painted in the Garden of Eden,

why couldn't George find a place for me in the bayous of his imagination?

Would I could push aside all that hanging moss, the thick heavy oil, the black oaks, which are just as real as the people—and for every two people a thousand ghosts!

six

THE WORLD OF MY PAINTINGS, BEFORE I BECAME AWARE OF BLUE DOG'S PLEAS FOR help, was a part naturalistic, part spiritual landscape that contained the images and the spirit of Cajun life, and history as I saw it.

Driven in the eighteenth century from their home in Acadia (Nova Scotia) by the British, Cajun families were forcibly broken apart, enslaved, and indentured in East Coast ports from New England to Georgia. The Acadian refugees finally found hope in the bayous of southwest Louisiana.

Here, the sky is very limited and always far in the distance; it reflects the circumscribed hope of my people, who came here only to find happiness. Here the people are locked in. They came here to escape, but now they cannot escape. And neither do they want to.

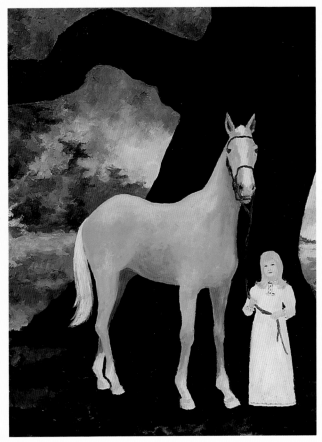

IN THEIR CAPTIVITY IS THEIR JOY.

IN THEIR FREEDOM, THEIR BONDAGE.

IN ITS WILL, THEIR PEACE.

THEY DO NOT, THEY WILL NOT, CHANGE.

The Cajuns are as much circumscribed by landscape as they are by history. The demarcation between past and present does not exist. Thus, I paint my people as ghosts. They really do not touch the sky; they do not touch the ground. They are suspended between heaven and earth. They are dulled down, kept in by the humidity, the mosquitoes, the swamp, the very rough life they confront every day with their hands. I paint neither bayou nor road. They both look the same and they are both pure black. This blackness represents the path, and this path leads to the sky, to the hope—a hope that tells almost nothing about itself.

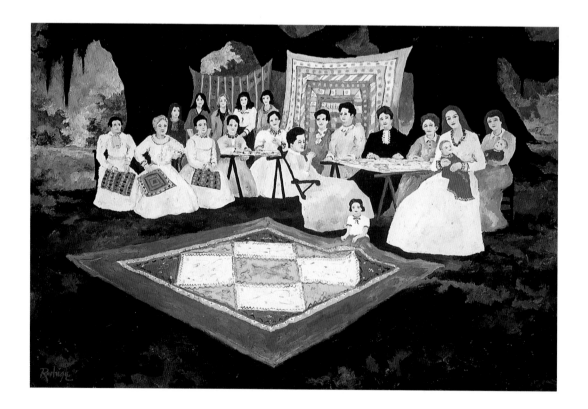

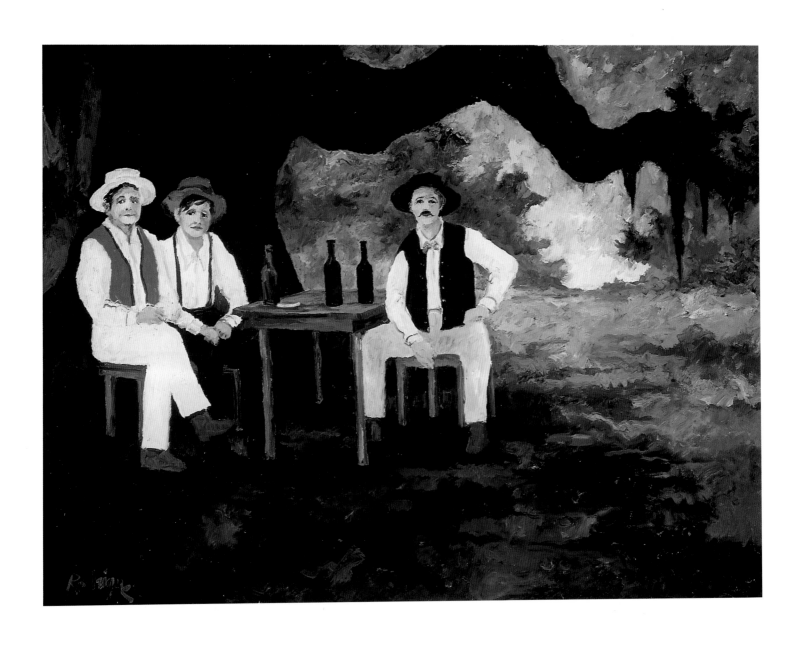

Man is caught in the middle.

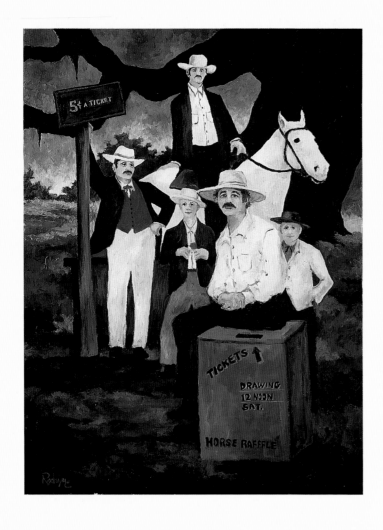

He will never get out.

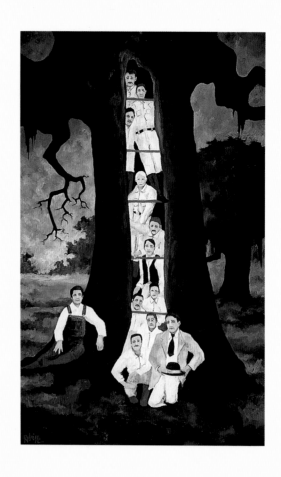

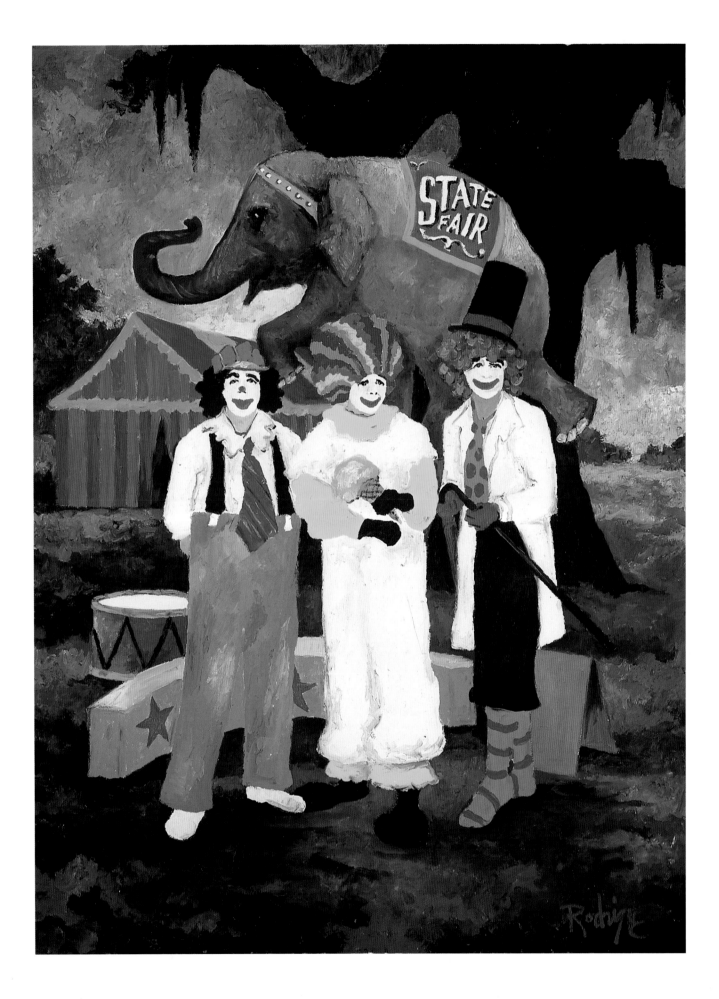

seven

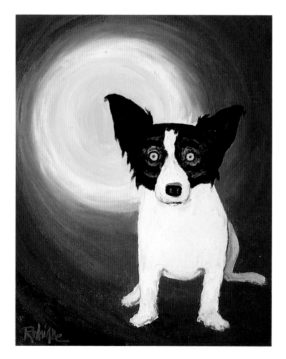

EVEN IN THE LIFE OF A DOG, THERE COMES A TIME when just one great idea can change the course of destiny—and surely I had hit on just the right one. With it, I would return to the sight of my master and learn from him to find my place of rest. Caught between earth and heaven, between spirit and flesh, between the known and the unknown, between hope and despair, I belonged neither to this place nor to that, to neither this time nor to any other. Only George could show me the way, and I did not even know what it was he needed to teach me. But one thing I knew. I must make him see me across the barrier of death.

For the first time since
my death, my path was streaked
with the **blue light of hope.**
But how was I to know that my
fanciful incarnation would
create a monumental *gaffe* of
mistaken identity?

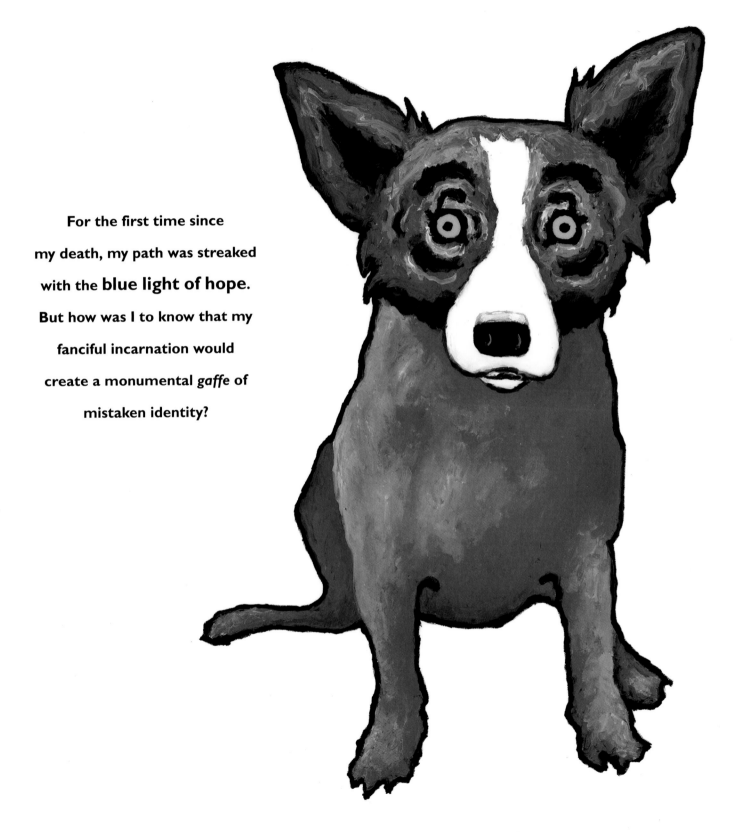

eight

"WHERE IN GOD'S NAME DID THAT COME FROM?" I WAS AMAZED. THERE, STANDING on the easel of my studio, was a portrait of Tiffany. At first I didn't recognize Tiffany's true identity beneath the camouflage my subconscious had imposed on her. Tiffany's love. Tiffany's death. Love and death. Death and love. They are either reasons to live or reasons to despair. And rather than face them head on, our subconscious veils the promise and the threat of love so that we do not have to look our responsibilities in the eye.

Without a conscious inkling of Tiffany's presence, I had begun to let "Loup-Garou," the legendary werewolf, alive in the myth and superstition of the French Canadians and the French Louisianians, influence my vision of Tiffany. It is said that a werewolf is a living person who has the magical power to change himself into a beast, and become a terrorizer, killer, and an eater of human flesh. One legend has it that Loup-Garou travels from place to place by riding astride giant bats.

I was utterly unconscious that she had somehow found a place to live within the world of my imagination, no matter how bizarre a metamorphosis my imagination had wrought for her. I had painted as if an ether-soaked gauze had been placed over my conscious mind, so that it wasn't until I had stepped back from the canvas that I knew what I had created. It was exactly as if I had been doodling on a

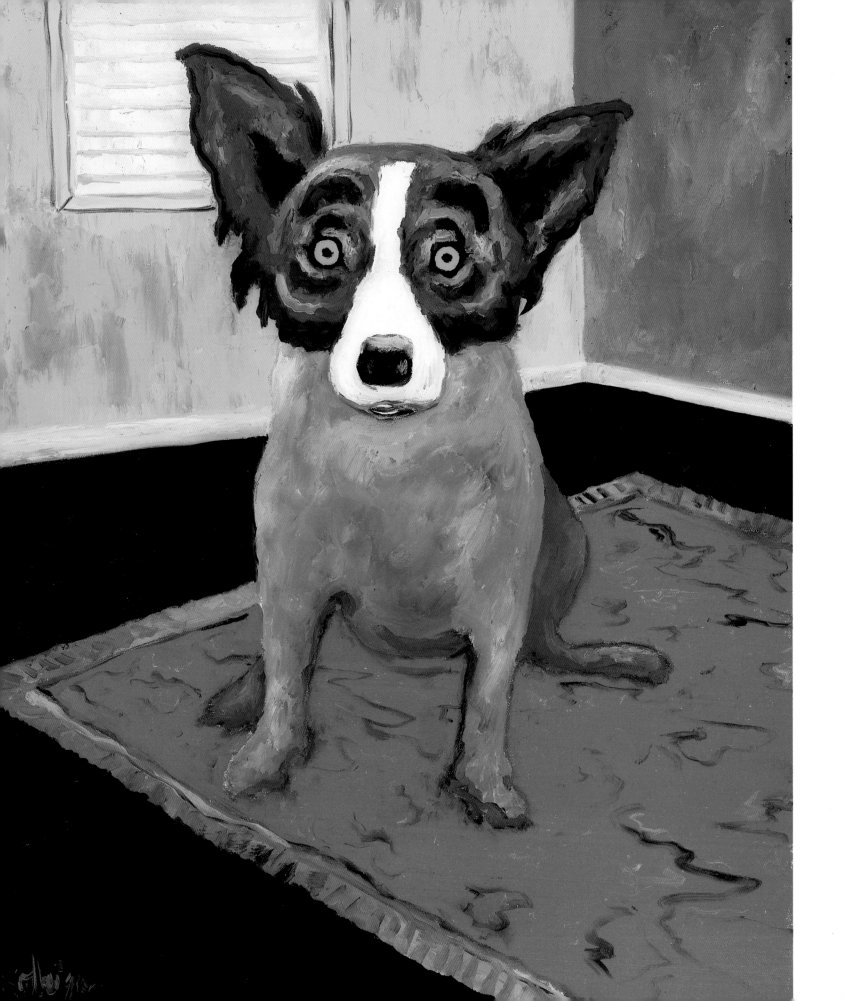

restaurant tablecloth and looked down to find a casting of my soul. What an odd mixture of anxiety and gratitude filled my heart. Since Tiffany's death, hardly a night had gone by when I didn't have some image of her infiltrating my dreams, and not a day went by when I didn't feel her presence around the house.

Presently, I was aware that Tiffany was calling out to me, and that our souls had developed a sympathetic vibration that was broadcasting itself in my work. And so, in that first painting, there she was, stuck like a label right on the surface, refusing to be dragged back into a landscape or melt into the ghostly past. She was bursting out, and I was determined to heed her, but fearful of surrendering to her influence.

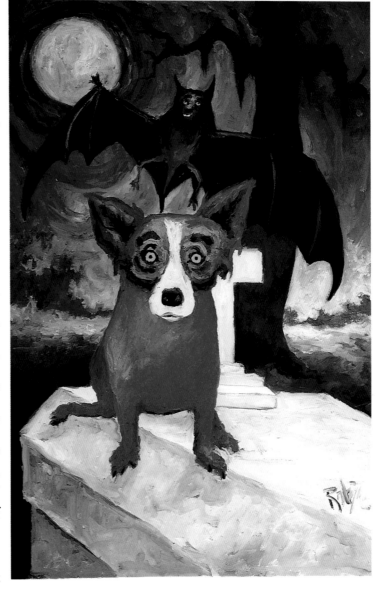

Even though I recognized that I was not painting Loup-Garous, in my subsequent paintings of Blue Dog, the melancholy, dark spirit of the werewolf tinged my vision. I painted Blue Dog among New Orleans's above-ground tombs, which, with their massive solidity, seem to float above the ground between life and death, states that to the Cajuns, who believe ghosts are real, are one and the same.

In the days and the weeks that followed, Blue Dog became an insistent ghost. For a Cajun who would bet on anything, like where a fly would land, or which rain drop would beat all the others down the window pane, I wouldn't have even whispered that I knew where this would lead me.

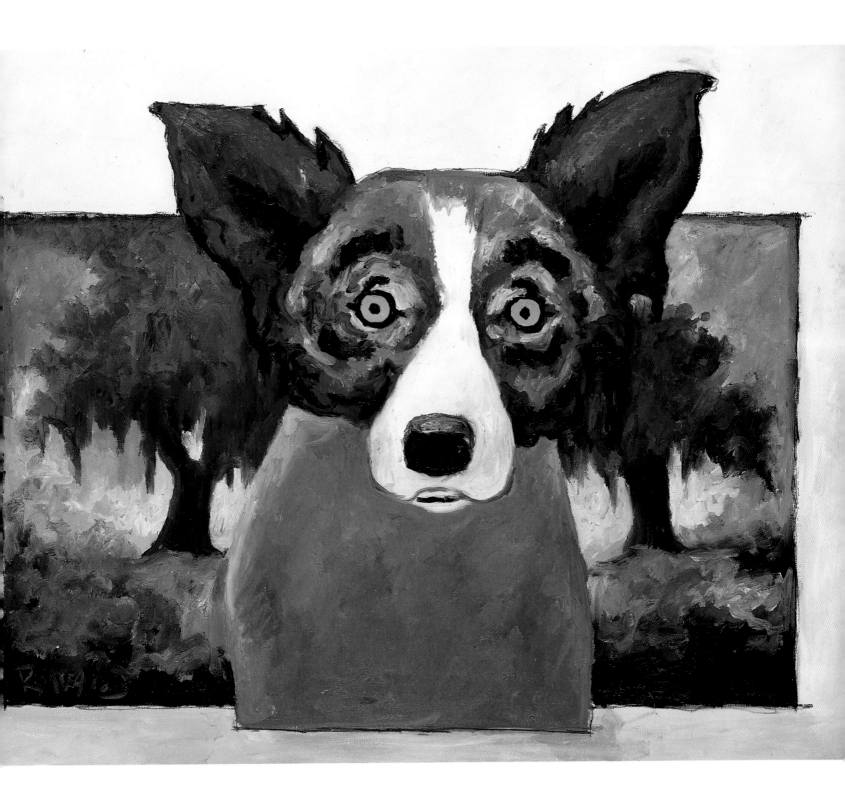

nine

I'd done it!

I'd gotten through to him, prompted him to search for me along the byways of his imagination, which for him was truly the gateway to the soul. I should have known that in the beginning George would handle my initial transmissions awkwardly. And his paintings showed just how much he groped in the darkness. First he pictured me as a murdering werewolf, and then he draped me out as a bewildered, lost soul, with no hope except that someone would come to my rescue. He'd put me in front of tombs, sitting on what looked like funeral slabs. He painted me climbing out of a cardboard box, set in the middle of a moss-draped, black-oak landscape; then he painted me in the gloom, illuminated by the eerie light of dripping candles or by moons crazed enough to chill the blood of Edvard Munch.

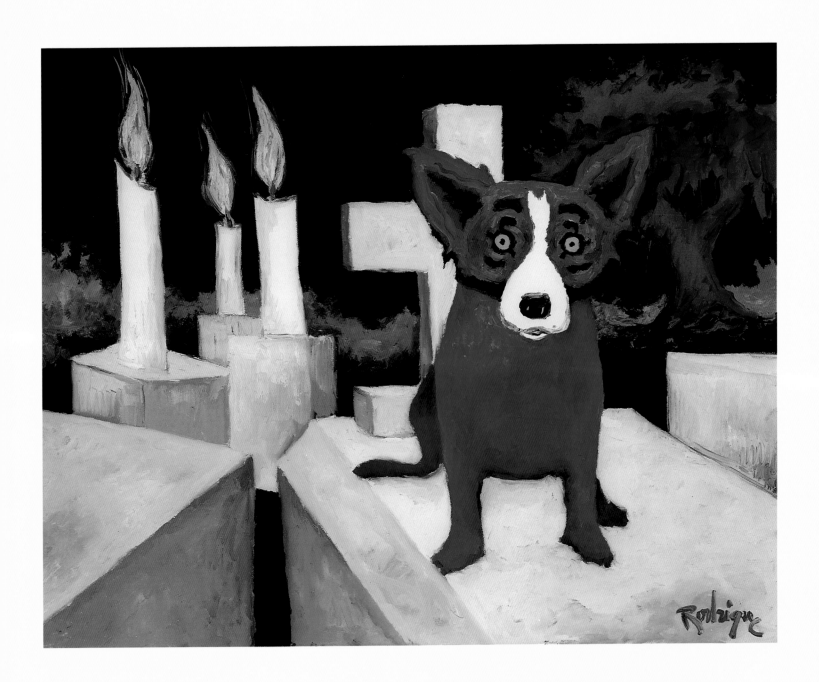

George was awakening to my whisperings, but with the confusion and discomfort you would expect from one who was reluctantly aroused from deep, deep sleep. His mind was still with the funereal Tiffany, not with the longing spirit of the Blue Dog, who asked not to be mourned but rescued, rescued and led home to the side of her master. I needed George to believe in my *enduring spirit* and to persuade him of the possibility of our communion. I cried out to him to toss off the weeds of death and believe that vital love was ours to share even across the void that separated us. "Come on George," I cried out. "Show me the way. Do not try to lock me away in cartons and mourn me in the light of candles and graveyards. I am become a spirit dog, a Blue Dog, in search of his master's love. And even though the path is long, we can travel it together with joy."

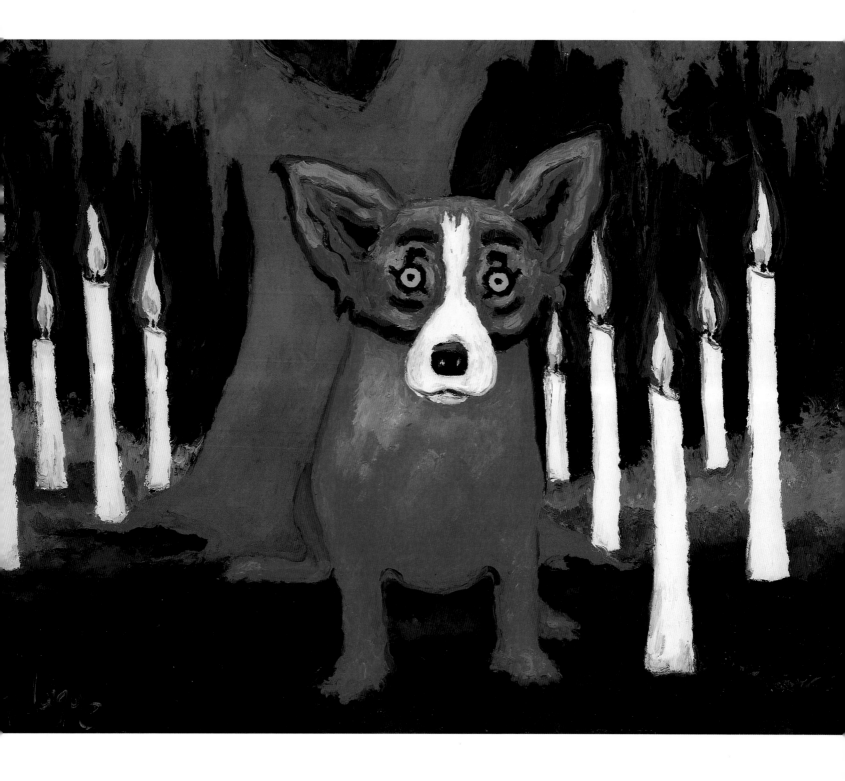

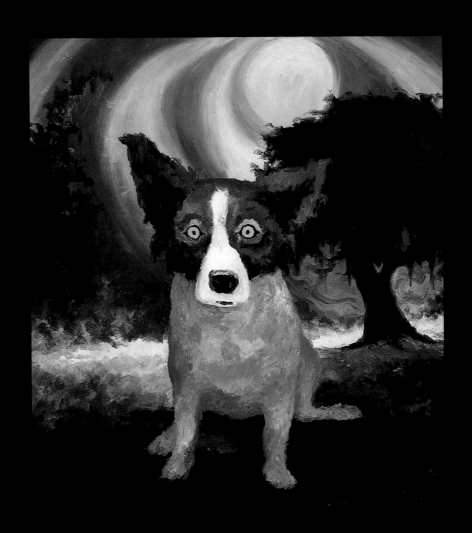

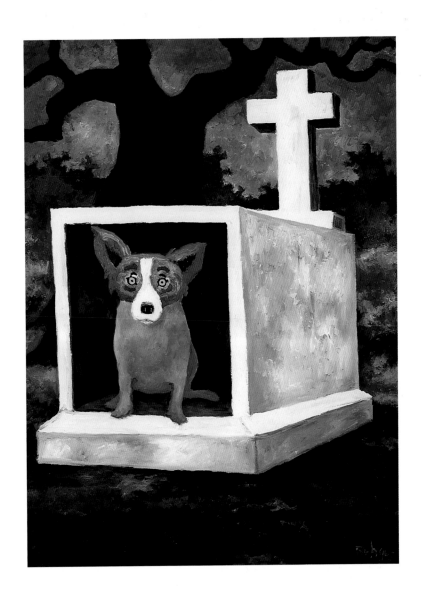

ten

By now I was convinced that Tiffany had not died. These intimations of her reaching out to me could no longer be dismissed as mere sentimentality or the after-effects of grief. As bewildered as I was, it was more disquieting for me to feel that it was I who bore the responsibility of curing her terror. I felt with my nerves what I could not explain with my brain—

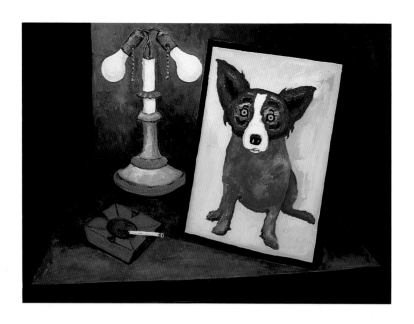

that my paintings could show her the way.

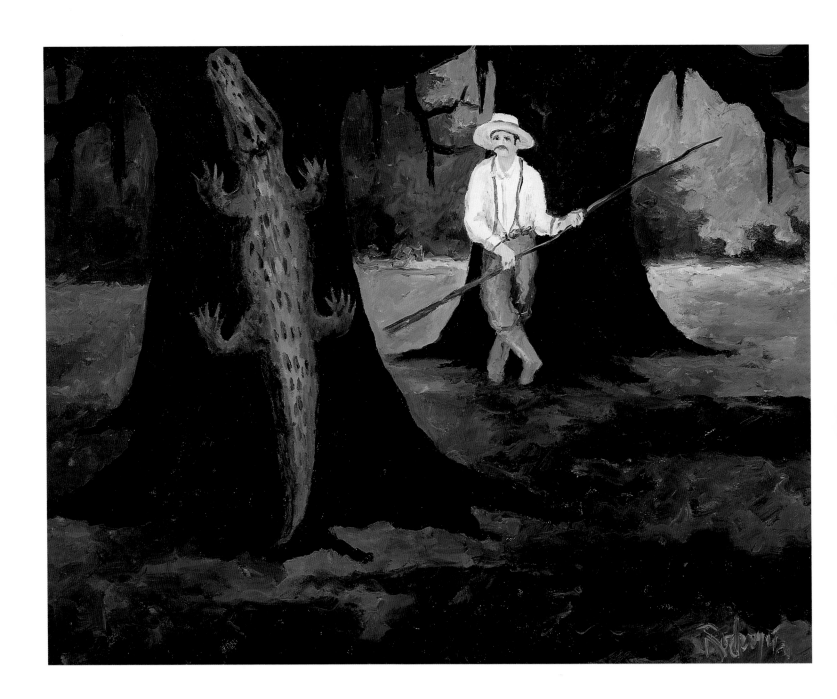

The burden that this put on me was more than I felt I could bear, more than I felt one soul could rightfully expect of another. Blue Dog was asking me to change; not only asking me, she was displacing my willpower with her own. Is there such a thing as a benevolent werewolf—a Loup-Garou not looking to bleed its victim to death but to share the blood that is the sacrament of humanity and the spirit that raises us above it? Would I lose myself by helping Blue Dog find her place in God's scheme? Or was losing oneself in the love of another not the loss of self at all, but the self's apotheosis? And, on a vulgar, practical note, what was this going to do to my painting, to my career—to the good prices I was beginning to fetch?

I was tempted to do the thing humans have traditionally done when they come face-to-face with the spirit: to kill the messenger rather than to follow it into the unknown. The temptation was overwhelming. And I knew from whence it came.

I had painted a picture I called "Clopha and Coco at Theriot's Landing," and for several days I propped it up on my easel and stared at its deadly message. It illustrates the Cajun tale of the fisherman who all his life had stalked the most powerful and wily alligator in the bayou. Each day, for many years, fisherman and alligator pitted their skills and strength against one another. They had learned one another's greatness and the hunt had given dignity to their lives. Then one day the fisherman caught the alligator. He strung him up to dry. Now the fisherman had his trophy, but his life was hollow without his companion spirit. That's what entombing Blue Dog in my paintings could do if I were to mistake her image for her spirit, if I did not plumb the depths, in which our flesh is but a vagrant squatter.

To show her the way, I would have

o let take the reins.

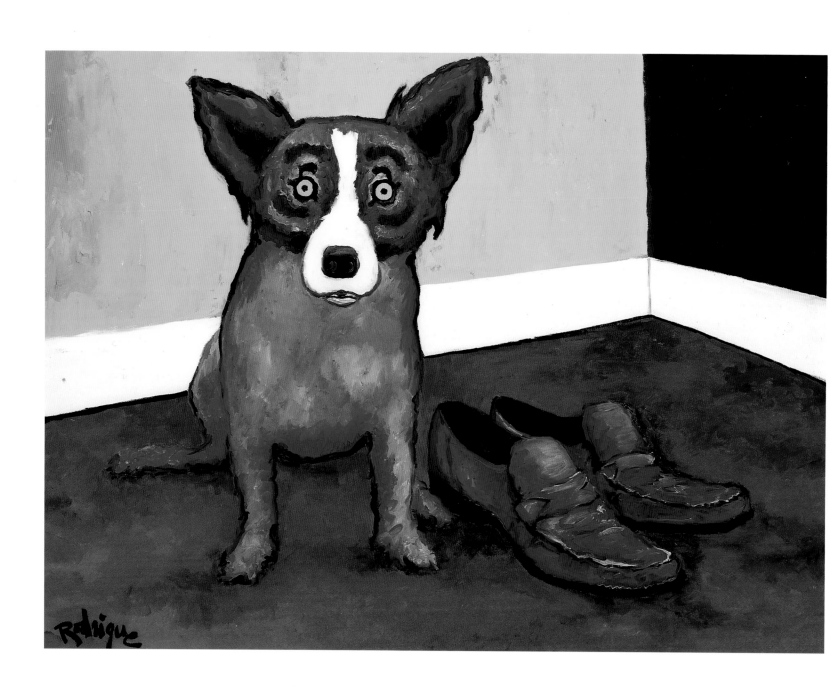

eleven

IT CAME TO ME FIRST AS NOISE—NOISE SO LOUD IT OVERWHELMED MY COMPRE-
hension, like when I was a puppy and first heard the screaming whistle of a fire engine or the
crash of summer thunder. It made my stomach vibrate, and I found myself making small yip-
ping noises as if the notes were strumming my whole body.

George has more sound equipment in his studio than The Grand Ole Opry. Whenever he
was painting—or, most of the time, when he was trying not to—he would turn up the volume
and let the sound of those "good old boys" wash over the cramped muscles of his imagina-
tion. And I never minded. When I was alive, bird chirping on a leaf-hidden branch could make
me nearly burst with excitement, but those Olympic-sized woofers and tweeters made me
feel as content as could be, as if I were curled up on the hearth in front of a crackling fire dur-
ing a cold November rainstorm. And now I was hearing it again. It was George's prime-time
favorite—not that it wasn't everybody else's also: Elvis's "Blue Suede Shoes."

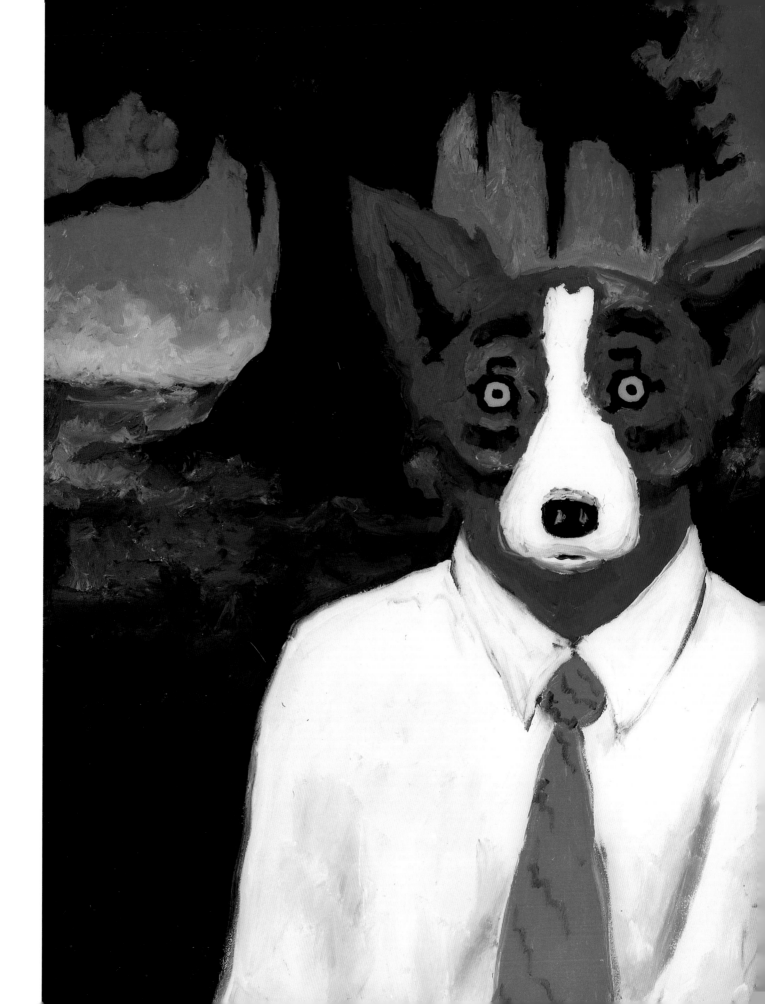

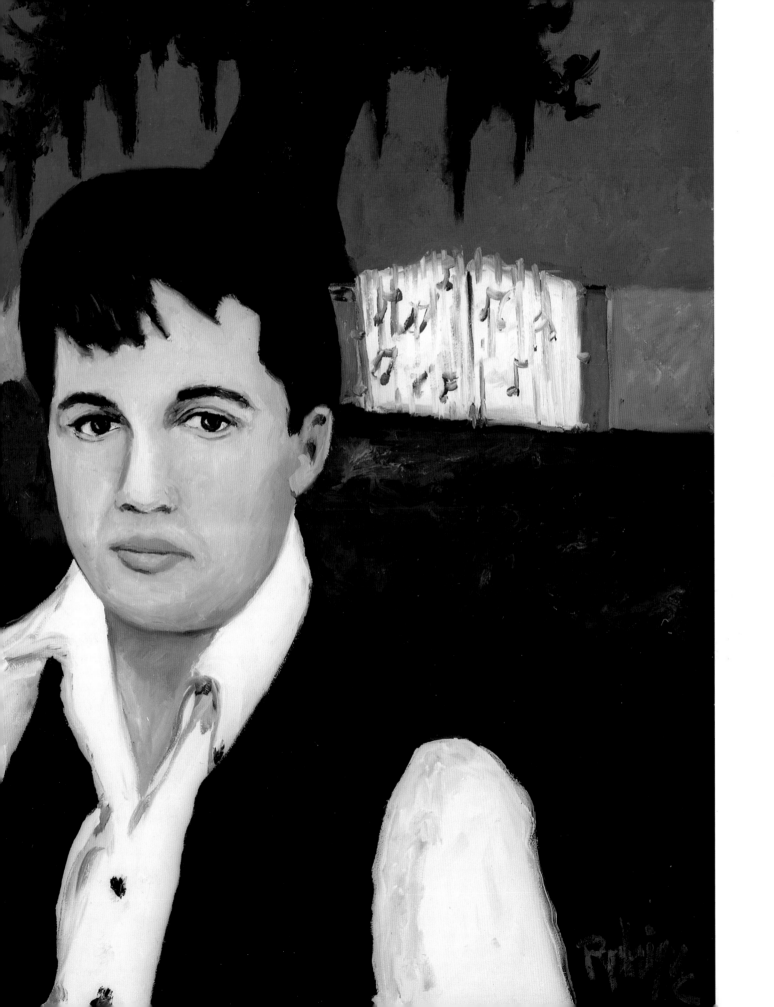

twelve

Elvis really had me going,

even though I had played "Blue Suede Shoes" almost as many times as I'd drawn breath. My mood was exultant, as though a fever had broken, and I had taken my first lungful of fresh spring air. I felt confident of my work, not frightened of what might lie ahead. A few weeks before I would have resented feeling in the control of a power greater than myself, but at this moment I just picked up my brushes and started to paint. I knew my joy was what Blue Dog wanted to hear.

Blue Dog. and Elvis

were departed and yet they were present, and no one could take their places, not even an impostor in werewolf's clothing. And as that music bounced off the walls of the studio, I tossed off any restraints I might have had in helping Blue Dog find the way. It was going to be a trip with lots of wrong turns, but if I kept the music loud and the colors bright, neither Blue Dog nor I would stray too far afield.

thirteen

AND SO GEORGE AND I HAD SET FULL SAIL AND WERE EAGER TO CATCH THE wind. I couldn't help but wonder where the seas would lead and what tempests we would endure. We had two captains at the helm of the good ship *Blue Dog*, and I just hoped that between the two of us we could steer clear of the rocks.

Being an amateur at steering souls, however, George probably thought that I'd like some companions along the way. So in his next series of paintings, George has got me talking to a bunch of animals: cows, rabbits, alligators, and roosters. I don't mean to seem ungrateful, but once you've been an animal and then become an intelligent spirit, barnyard conversation seems a bit limited. When I told the rooster that I was trying to get back home, he told me that as much as he'd like to help me he couldn't move from his perch because he would lose track of the sunrise. The cow was kind and placid enough, but told me she would burst if she didn't get milked every morning; and the alligator, while he was all smiles, tried to lure me close enough to his dripping jaws to make further conversation unnecessary. But the rabbits were an unexpected source of inspiration.

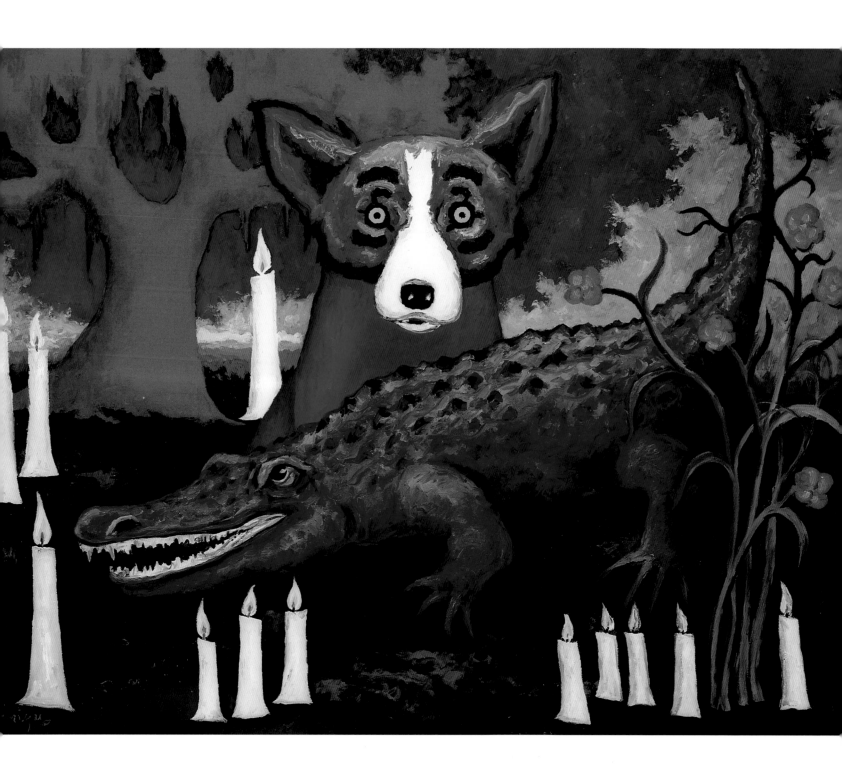

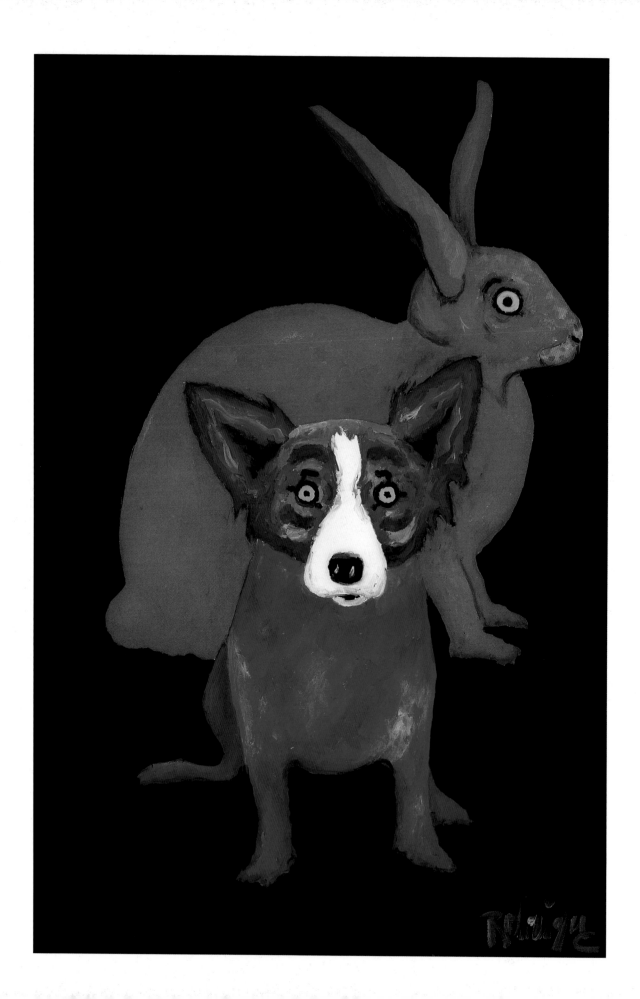

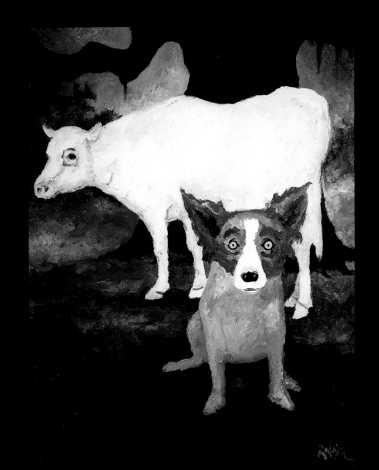

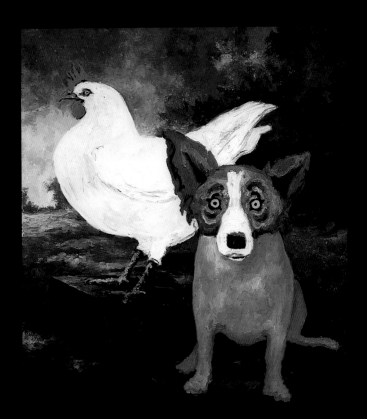

fourteen

TRYING TO TUNE INTO BLUE DOG WAS LIKE TRYING TO LOCK INTO A FADING RADIO signal in a thunderstorm. Blue Dog was an animal, so I thought she could easily find camaraderie with other animals, especially a pair of black and white rabbits who used to belong to a touring magician who once worked the back roads of New Iberia, Louisiana. These rabbits seemed to be able to read the mind of anyone in the audience. I got to know the magician who used them in her act. She was a *traiteur*—that's what the Cajuns called their traditional doctors. Each *traiteur* treated only one kind of ailment. There would be a *traiteur* for sprains, or noses, or stomachs, and the best thing about the *traiteur* was that you didn't have to believe in her powers: if the *traiteur* herself believed in her own powers, then the cure would work. I was guessing that some of her magic had worn off on her rabbits.

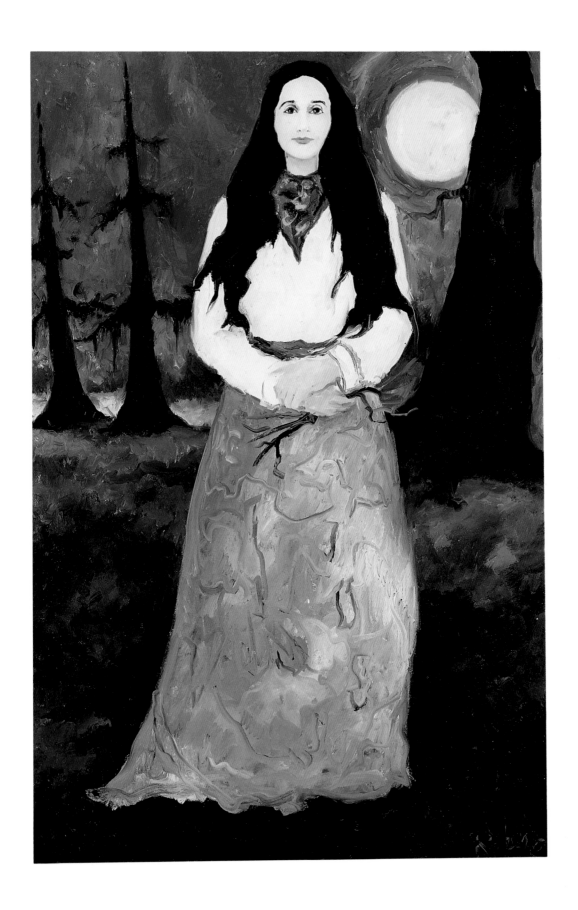

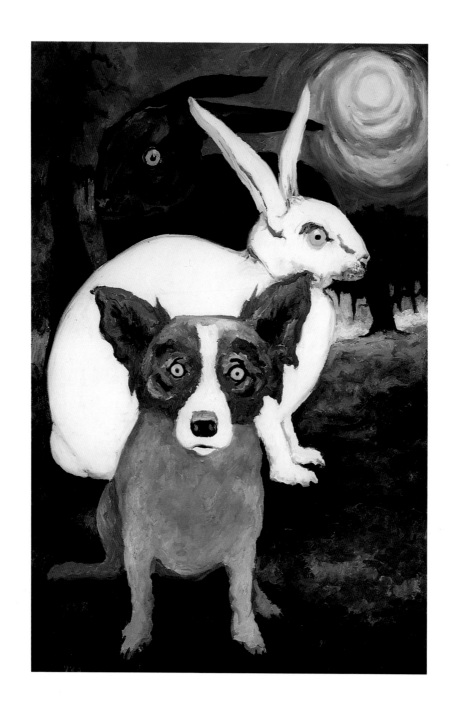

"YOU DIED, DIDN'T YOU?" THE WHITE RABBIT SAID.

fifteen

"You died,

but you still haven't

found rest,"

said the black one. I was flabbergasted, and more than a little bit afraid. When I asked them how they knew that I still wandered in search of peace, they told me of their lives with the magician-doctor-*traiteur* and how she had the gift to share with them knowledge about a life that spans beyond our earthly days. As happy as I was to have such companions, I couldn't help but ask why they did not continue to search for their mistress. They looked at me with tenderness and compassion, as if they bore a weight of knowledge they would not share because of the pain it would cause me. The white rabbit said, "For me the path has already been too arduous, and I am content with what I am." And the black rabbit said, "The magician-doctor gave us the balm of death, and we seek nothing more."

"But is there not still more she needs to tell you?" I asked. But they looked away from me, and did not reply.

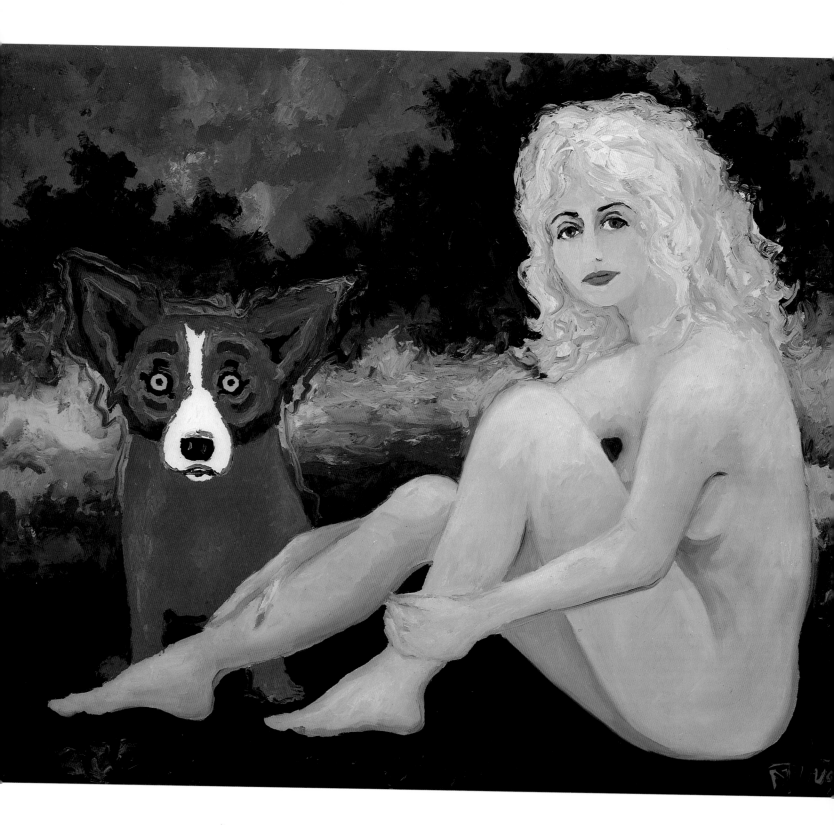

sixteen

It was at this time, just when Blue Dog must have wondered why she alone, of all the souls she had met on her spiritual wandering, could find no peace or reconciliation with her master, that the transmissions between us caused me the greatest perturbation. I would toss and turn in my sleep, and even by day, with the refulgent north light bathing my studio, my heart tripped out of beat with an anxiety I could not define. It was then that I painted a series of sensuous nudes—voluptuous odalisques who might have found their origins in Rubens or Ingres. And, right alongside them, wide-eyed, bewildered, seeking companionship and love, sits Blue Dog, as out of place as love always is when sought in all the wrong places. What in the world was going on? It was only many months later, after much agonizing, self-chastisement, and, finally, professional guidance, that I began to get a grip on what must have been happening.

Not only was Blue Dog's soul trying to enter mine, but mine was reaching out to hers, and what was common to our search was our mutual and equally fervid search for love. And with the boundaries between her being and mine dissolving and reappearing like clouds shaped by the wind, my own dreams of erotic love mixed with Blue Dog's search for divine love, which needs no flesh to be real. And so, like the symbols in a dream, which do as much to hide meaning as to reveal it, these sensual images were projections of my as-yet-inadequate ability to meet Blue Dog's spirit face-to-face.

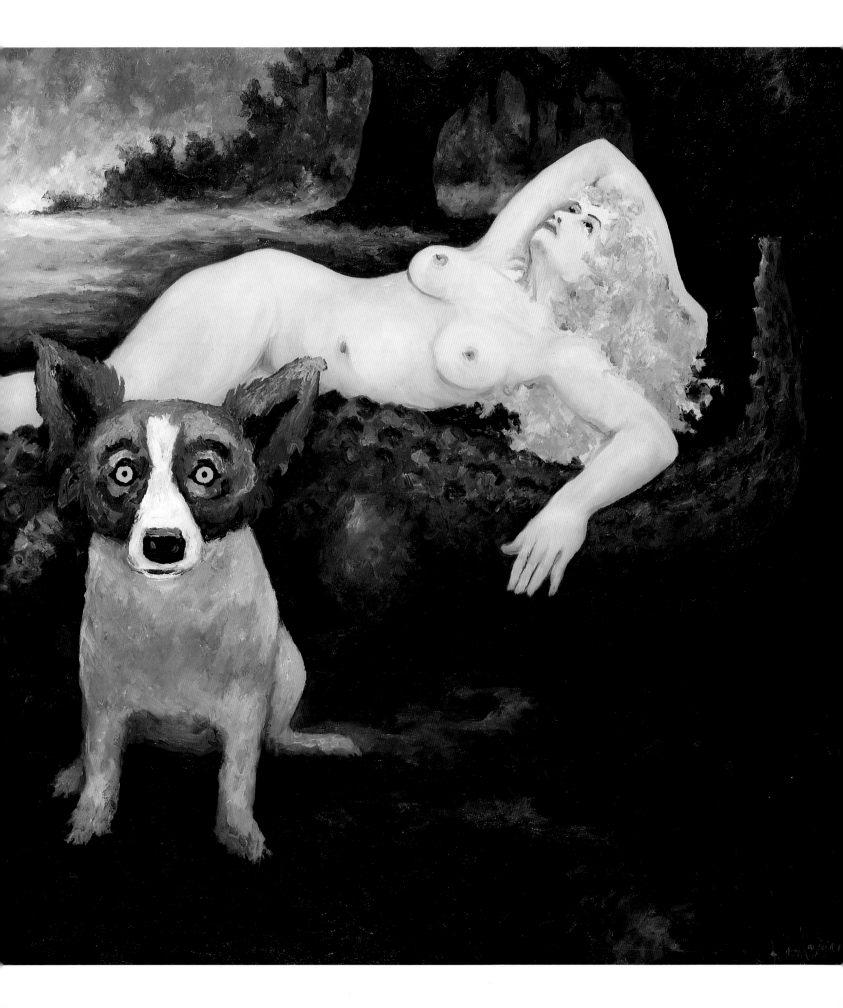

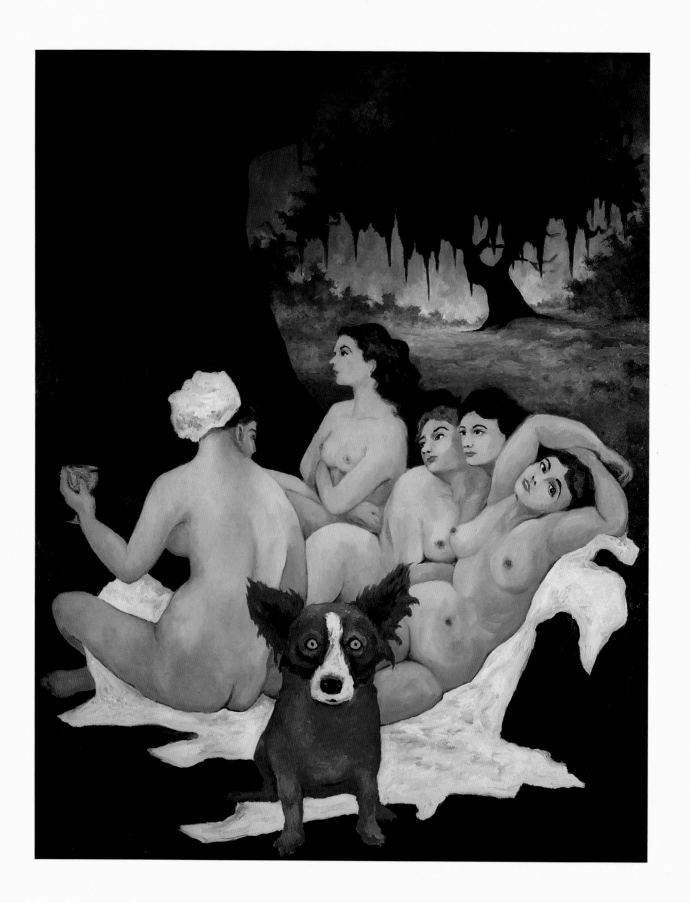

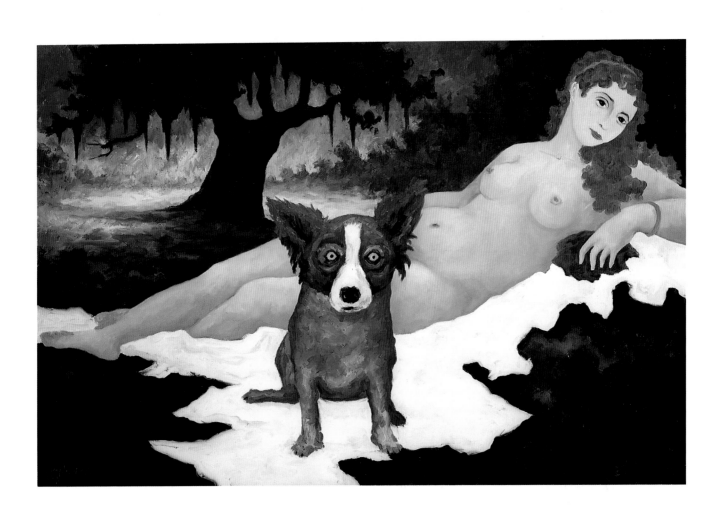

And I wondered when we would meet face-to-face, and not as through a glass darkly.

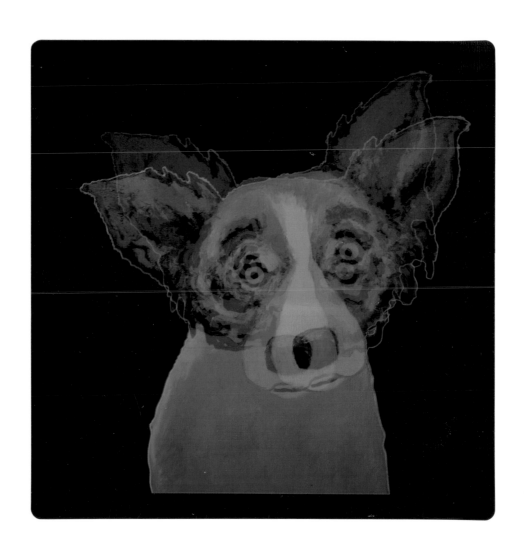

seventeen

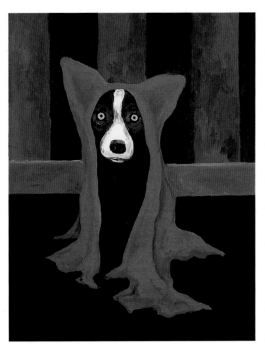

TO A CAJUN, THE HEALING POWER OF THE MAGICIAN-DOCTOR REMAINS unquestioned. **Not even George's university education could dismiss this deep-rooted belief.** Incantations, spells, cures that defied all modern reasoning couldn't embarrass George, no matter how much his busy life had come to engage him in the commerce of the world beyond New Iberia. And so I was not entirely surprised that in pivotal paintings of this period George had begun to dress me up in disguises that I believe were meant, like the homeopathic medicine of shamans, to instill me with their powers.

First there was the one of me clothed in a voluminous, apostolic red cloak (like the one a Renaissance cardinal would wear): perhaps George was hoping to invest me with enough ecclesiastical influence to secure me a seat in heaven. In another painting, the religious robe of the prince-prelate turns into the magical cape

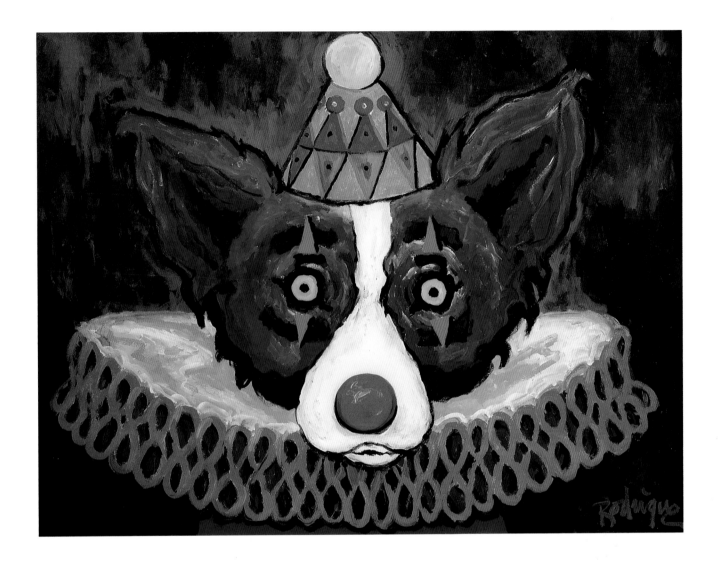

of a stage prestidigitator. Was the cape meant to give me the power to fly beyond my predicament or, perhaps, the *traiteur*'s secret power to cure me of my soul's sickness?

In yet another disguise, George has me draped out in a Mardi Gras mask, gold pendants, beads, and pearls, perhaps to give gaiety to the season of deprivation before the spirit returns to its home in heaven. And in another he decked me out in the raiment of Pagliacci, the clown who hides the sadness of frustration and loss.

But for all George's efforts to provide me a disguised entry to the place of my desires, it would be only naked and unadorned that I would pass through the portals for which I searched.

eighteen

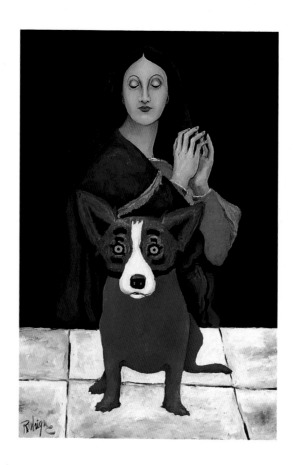

AS THESE COSTUMED IMAGES OF BLUE DOG EMERGED FROM MY PALETTE, I UNEASILY began to recognize that in putting costumes on Blue Dog, I was diverting my eyes from her spiritual reality, for which I had no available image and for which none might exist. For an artist obsessed with volumes and light, the difference between essence and ephemera can soon be muddled. Perhaps that is why the ancient Israelites forbade all graven images of their God, for then they would worship what they themselves had wrought rather than Him who was their maker. Perhaps the communion between Blue Dog and me was to be apprehended not through imagination but through prayer.

But torn between **prayer** & *imagination,*

an artist like me, too vain to subordinate

his imagination to a higher power,

will always make the devil's bargain.

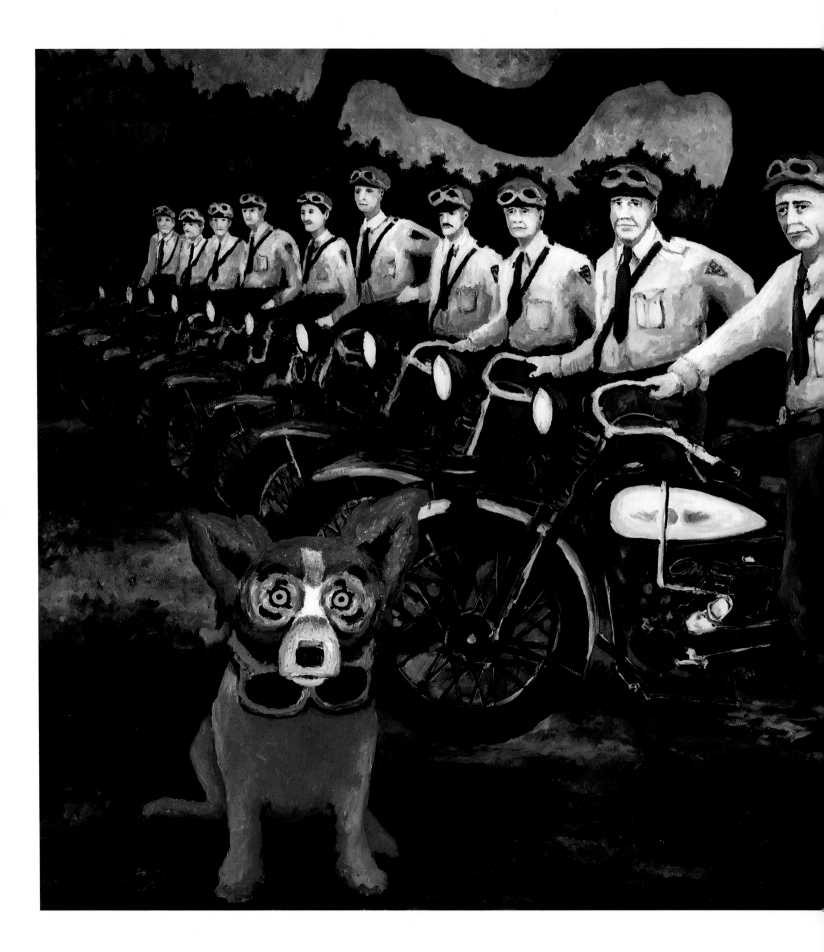

nineteen

NOW THAT GEORGE HAD FIGURED OUT THAT IT wasn't a change of costume I needed, you'd think he would have figured out that a change of venue wasn't going to do the trick either. Like an alcoholic who ceaselessly moves from one town to another in the hope that he can leave his trouble behind, George was taking me on a "geographic." The trouble with geographics is that the sickness lies with the traveler, not the place. So I figured that George was hoping to speed me into a new life by speeding me to a new place. And to set me off on my journey to the rude towns and empty horizons of the West, he even provided me with a Louisiana state police motorcycle escort.

twenty

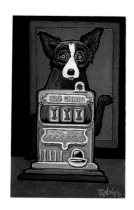

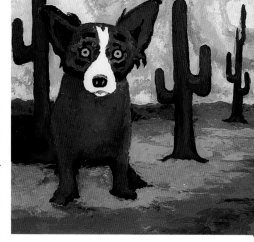

<small>PERHAPS I THOUGHT THAT IN THE FREEDOM OF A NEW LAND,</small> Blue Dog would sniff out new options, pioneer a new path to the home she sought. Surely painting Blue Dog in brand-new vistas and confronting her with challenging and exotic situations seemed to hold out the promise of a new life.

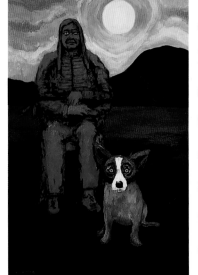

But as I look back at those paintings, I can see how even as I tried to give her a new freedom I was teasing her into blind alleys and false trails. Whatever spiritual quest Blue Dog was on, its successful conclusion would not involve changing her outer raiment or giving her an exotic itinerary. Indeed, I would come to recognize that only by casting aside the outer world and joining her in a surrender to a love that was beyond our comprehension, would we both be rescued from our discontent.

In the painting of the dance-hall dominatrix, Blue Dog's back is turned on the temptations of the flesh, which are the real manacles, shackles that, unlike the steel ones that bind her, cannot be released by mundane device. In the portrait of the aged Indian medi-

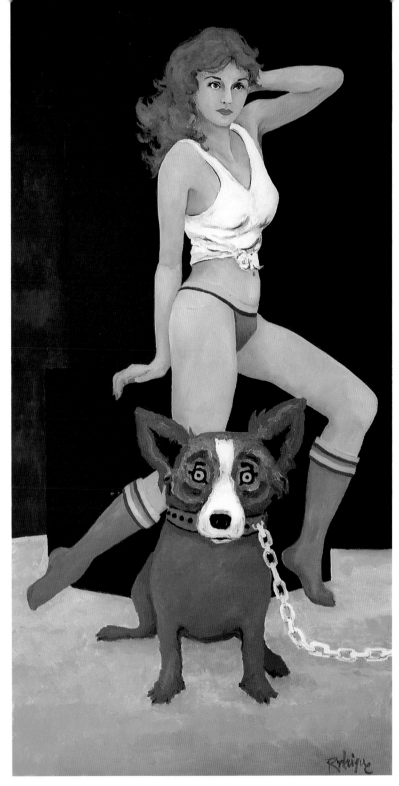

cine man, to whom so much seems to be known, Blue Dog sits stolidly, unenlightened, as if to say that even the greatest wisdom of man cannot secure her the knowledge to reach the true end of her journey.

The enigmatic portrait of Blue Dog playing the one-armed bandit is rife with meaning. Notice that there is no money in the pay-off dish, even though Blue Dog has come up with three of a kind. And of what are those three matching slot machine symbols made? They are made up of dog biscuits shaped into the letter "I." Clearly the big payoff for both Blue Dog and me would not be forthcoming until we could break through the tyranny of the ego—the triple "I" of self-absorption, which makes us feel that by individual assertion alone can serenity be found.

Finally, in the landscape with the trinity of almost cruciform desert cactuses, Blue Dog, alone in her predicament and with her back to the desert environment, has begun to stare back at . . . I could hardly stand the emotion of this realization . . . to stare back at me. And in that stare I felt a keen reproach, that in binding her to the tethers of my imagination, I had kept her chained to a world in which neither she nor I knew the way.

twenty-one

GEORGE WAS BLAMING HIMSELF FOR BEING A FALSE GUIDE.
But in truth it was I who had asked him to be a god rather than a guide.

To a dog, man is as a god, but to God man is but a supplicant.

George is my master, but he is God's servant. In the series of paintings that follow, I found that George's preoccupations had lifted from his vision of me. The dreams of his unconscious mind, even with their lusts and curiosi-

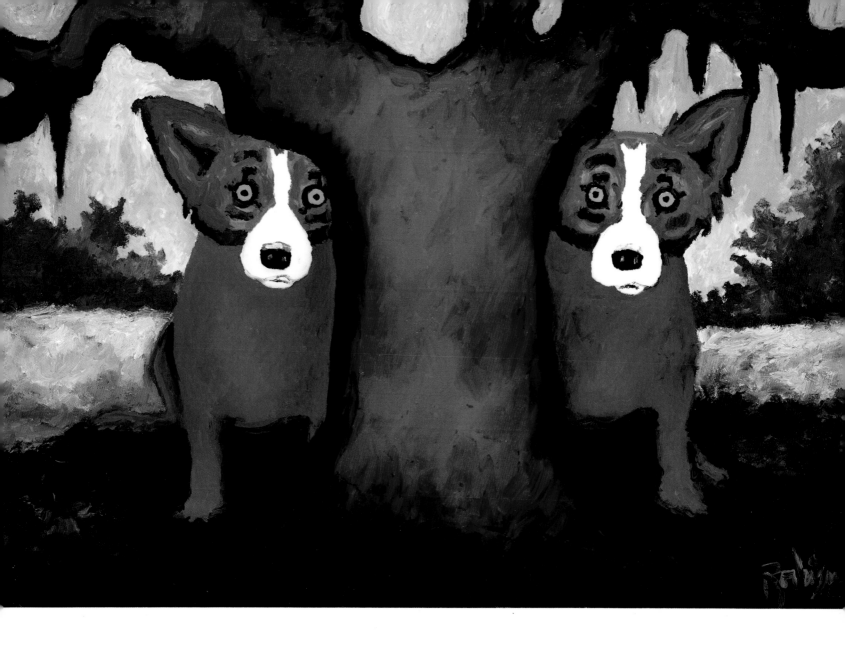

ties, no longer entangled me in an embroidery confusing to both our lives.

But I did not feel abandoned; rather, a sense of serenity and fulfillment swept over me, as though in George's letting go he had freed me to seek my destiny according to my own nature. My mind turned back to that far-off encounter with the black and white rabbits, and I remembered what they had said when I somewhat petulantly asked why they had stopped seeking their master: they told me that they had ceased their toil because their master had found peace. It had taken a while and many turnings of the road, but now I understood their message.

twenty-two

HOW IS IT POSSIBLE THAT IN THE DOZENS OF PAINTINGS I had done of Blue Dog, I had not understood their most obvious clue? I had painted Blue Dog in bayous and deserts, in sunlight and dark, with voluptuous women and with families of Cajuns, in weird costumes and as an unadorned real-life dog. The world I had painted around Blue Dog was various, filled with the paraphernalia of my own experience and psyche, but in not one of them—in not a single one of them—does Blue Dog pay any attention to the world inside the paintings. In every single painting, Blue Dog sets her soulful and mournful golden eyes straight ahead, away from all objects enclosed within the frame. In every painting Blue Dog stares at me. Though I had provided her a world populated by the riches of my imagination and my craft, she was diverted by none of it. She wanted only me. And as willing as I had been, I had not known how to surrender myself to her needs. Her way was with me, and I could not face up to it. For who can bear the burden of unconditional love?

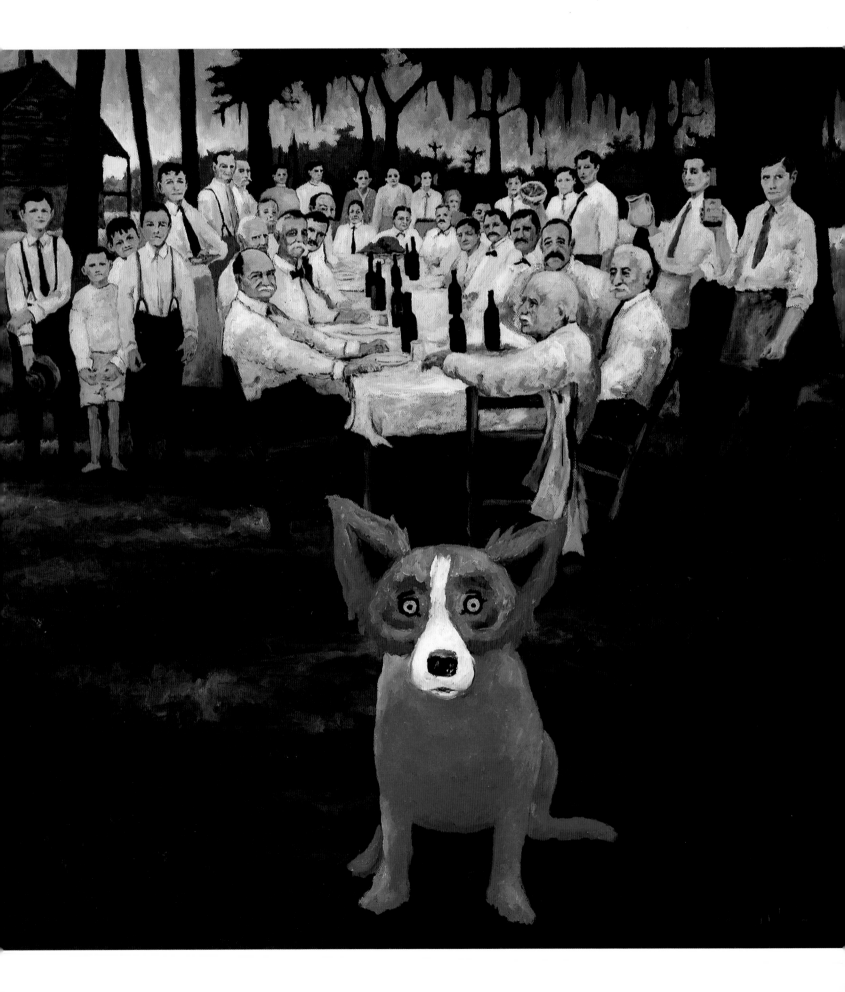

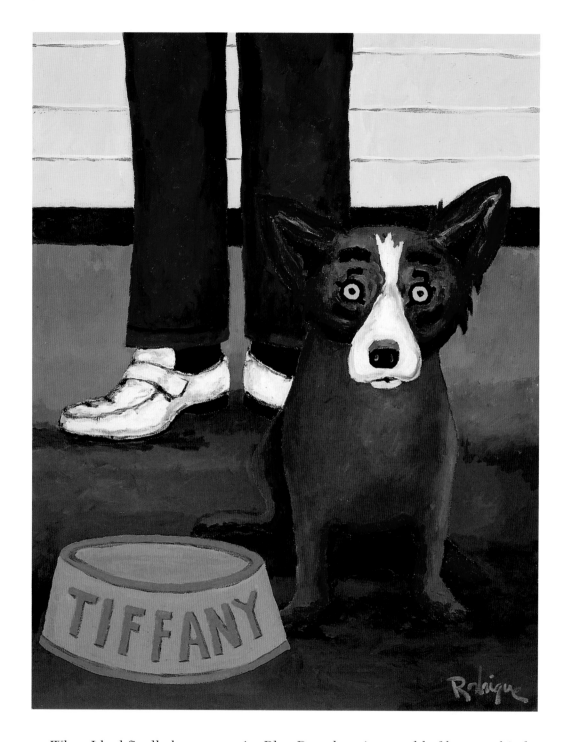

When I had finally begun to paint Blue Dog alone in a world of her own kind,
I sensed that Blue Dog was giving me my freedom—freedom not so much to
love but to accept love from the infinite bounty of a dog's heart. I might be her
master, but to my own master I was only a servant.

AND AS I WAS TO BLUE DOG,

WE LOVE

SO WAS I TO GOD, SAVED ONLY

BY BEING

BY ACCEPTING HIS GRACE.

LOVED.

THAT IS THE WAY.

twenty-three

I COULD FEEL THE PEACE THAT HAD DESCENDED ON GEORGE'S SOUL flood into my own. I was receiving a vibrant communication from him, broadcast loud and clear, uninterrupted by wavering signals and confused messages. I knew at last that, like the toad in the aristocratic English painter's studio, I was included in his life and that my love for him was fully accepted. I knew that he would love me forever, and that trust would leave no place for fear.

It was in the warm serenity of our true reunion that George painted Blue Dog, the spirit-wanderer, Black-and-White Tiffany, the flesh from which the spirit dog arose, and Red Dog, the primal energy that infuses both flesh and spirit and that is the stuff of the cosmos.

I will never forget his face, on which I had set my gaze all the days of my life. Across the barrier of death I am reminded that the journey I began as Blue Dog began with my love for my master.

And so as George continues to paint images of Blue Dog, he does so with the conviction that he has shown me the way, because

love that resides in the sight of our master is equally holy for all **His** creatures.

George has given me
the freedom to find my
place in his paintings,
but my search for him
is no longer restless, for
the place we find when
we search for love is
our home forever.

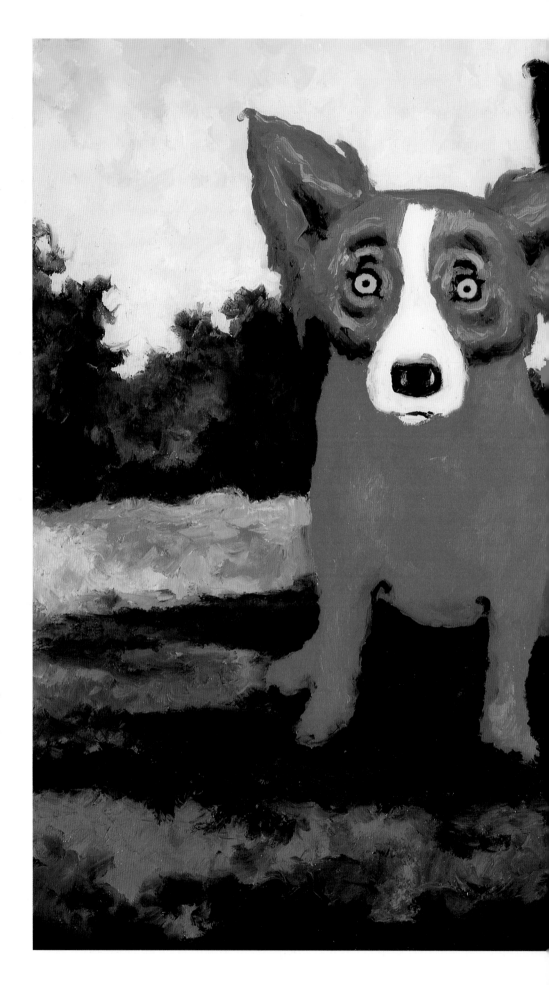

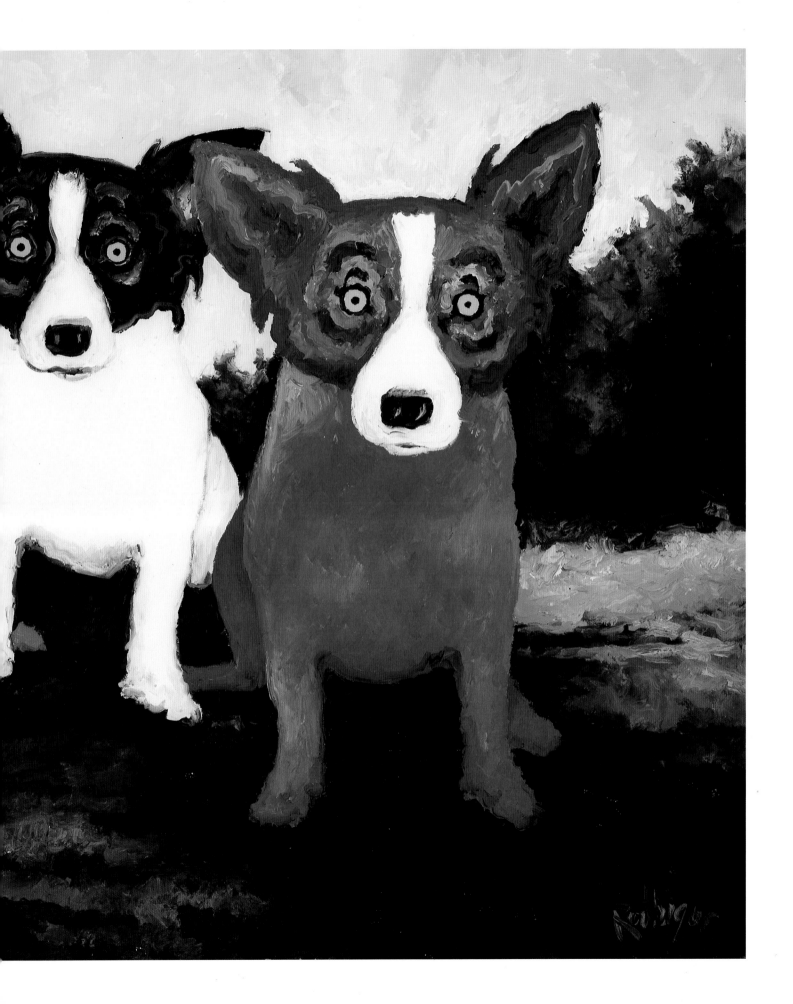

epilogue

I T I S T H E S E A S O N O F M A R D I G R A S , A N D I , T H E S O N O F C A J U N S , T O W H O M A S A F E haven in the remote bayous was all his ancestors asked of life, have been crowned The King of Mardi Gras. As the parade wends its cacophonous way through the streets of *La Vieux Carré*, I sit like a reigning monarch, high above the costumed crowd. The intoxicated revelers lose themselves in the intensity of their celebration, fending off for one more day the Lenten humilities required to prepare themselves for the blessings of Easter.

Of course I am proud. Of course I am filled with gratitude for having come so far. But I watch the festivities with only half my soul. Occasionally my hand reaches across to the side of my throne and comes to rest on the head of Tiffany, the Blue Dog of my heart, who rides with me in triumph for all who have the eyes to know that she is with me.

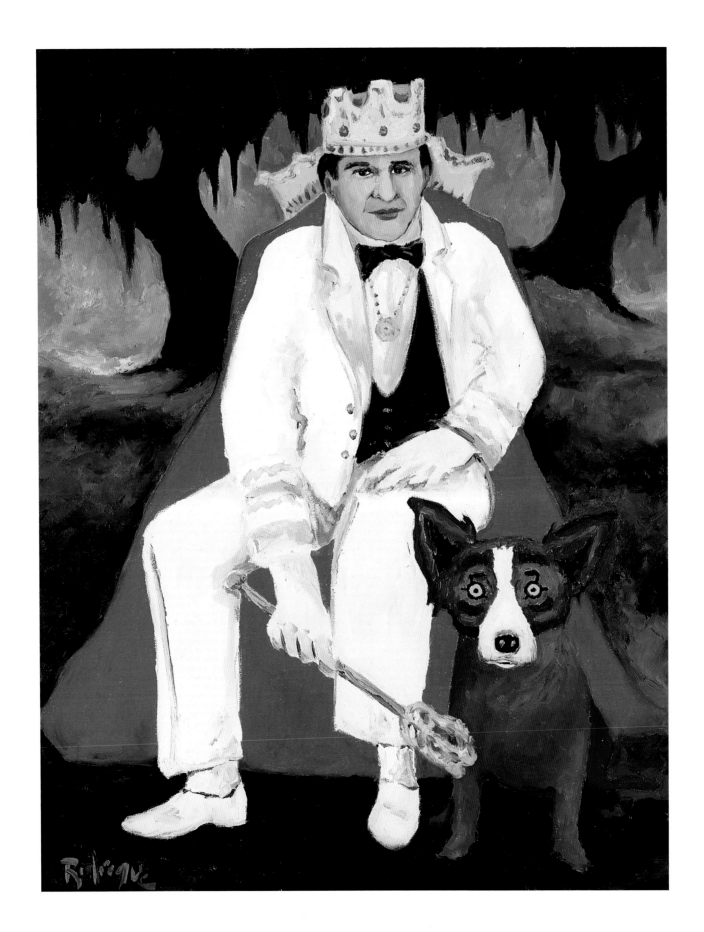

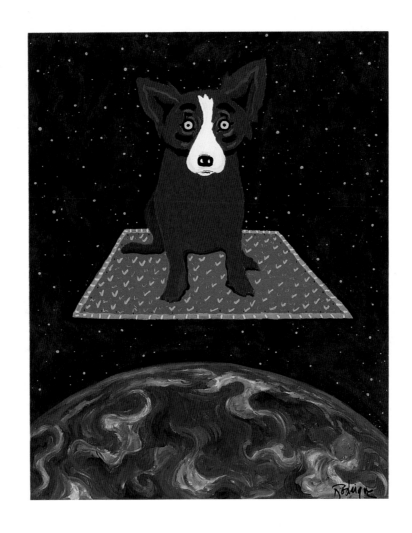

finis